THIRTIES

The Album in Portrait and Prose

THIRTIES

The Album in Portrait and Prose

Jill
ANDREWS

Foreword by Joy Williams

DEXTERITY
NASHVILLE

Dexterity, LLC
604 Magnolia Lane
Nashville, TN 37211

First edition: 2020
10 9 8 7 6 5 4 3 2 1

Printed in the United States of America.
ISBN: 978-1-947297-16-6 (trade paper)
ISBN: 978-1-947297-17-3 (eBook)

Lyrics: Jill Andrews from *Thirties*, the album
Artist Management: Erin Anderson, Olivia Management
Legal: Jeff Colvin, Marcus and Colvin, LLP
Content Editing: Shannon Lee Miller
Photography: Fairlight Hubbard
Thirties album cover design: Fetzer Design
Cover and interior design: Jeff Godby

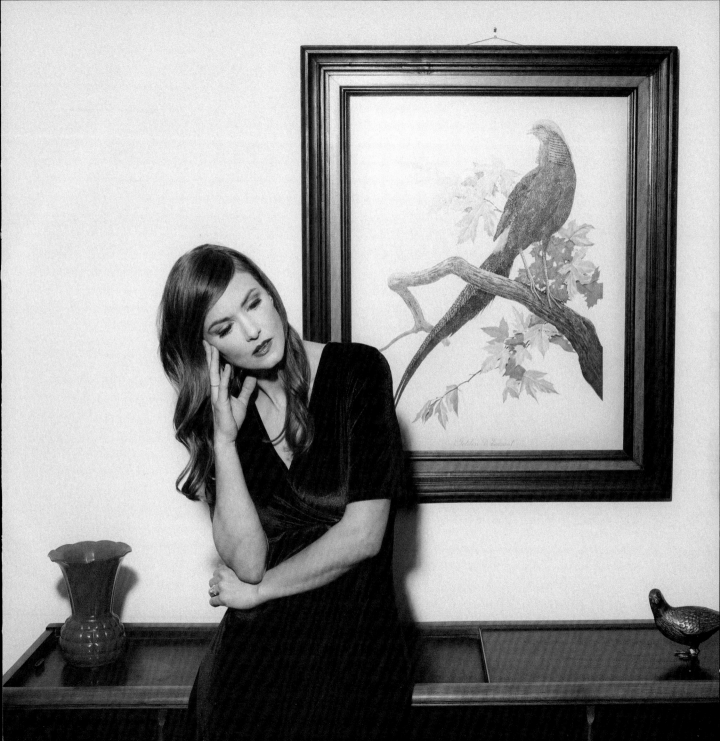

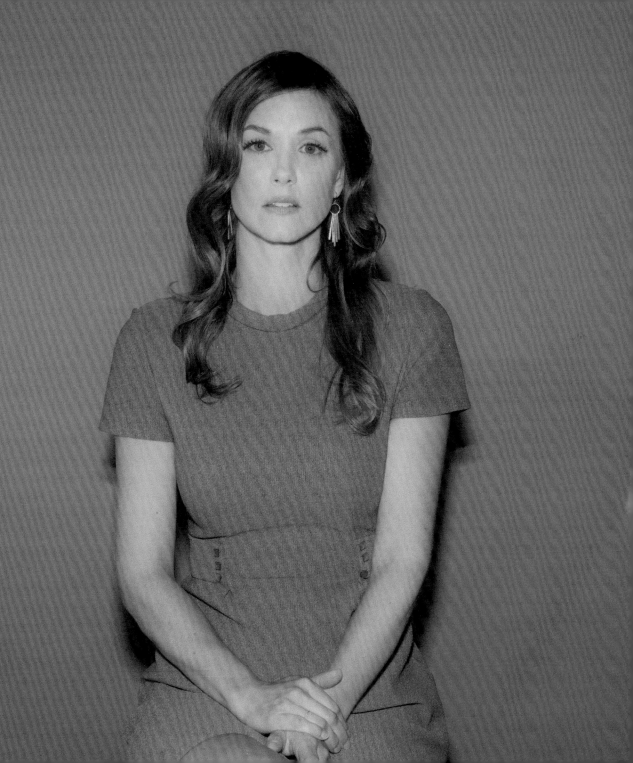

This book is for:

My parents,
who have lent more helping hands than I could ever high-five,

My children, Nico and Falcon,
who have taught me to slow down and listen up,

And my husband Jerred,
for appearing out of thin air and changing my life forever.

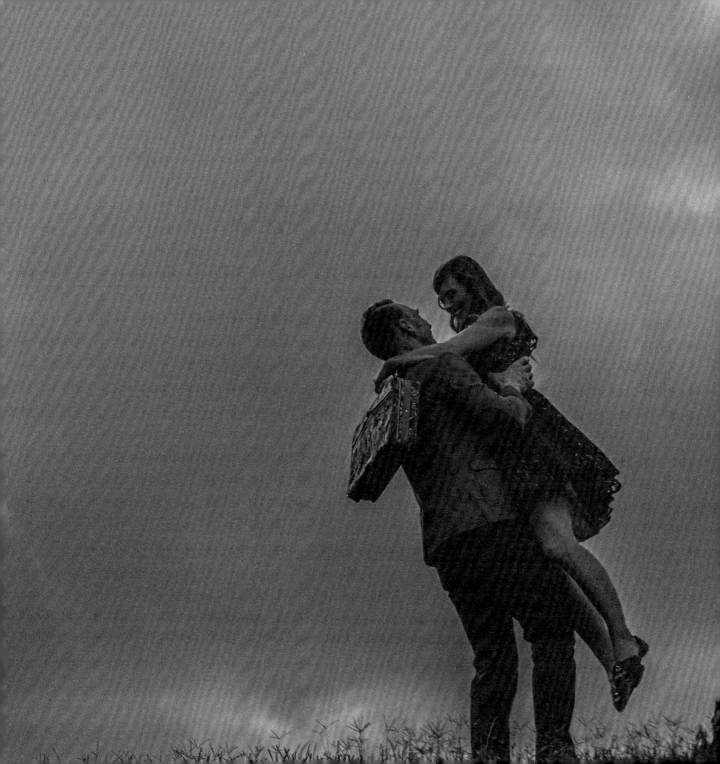

Foreword

When I was just starting out in The Civil Wars, I remember meeting an easy-going soul named Jill Andrews. She opened up for us in the cozy, high-ceilinged venue at the Square Room in Knoxville, Tennessee. Jill's spirit radiated—her eyes twinkling with something like a wonderful cocktail of curiosity and "here I am" groundedness—when we spoke that first time. And then she opened her mouth and sang on stage. I was struck by her ease, her lilting melodies, this songbird contented to be rooted to the earth.

That was almost a decade ago. In a little-big-town like Nashville, you'd think we'd have run into each other more times than we could count. But we didn't. It was three years ago when our paths finally crossed again on the autumn leaf-kissed sidewalk of the school where both our sons attended. There, day by day, as we carried lunch boxes behind boisterous sons running ahead of us to their classes, we began getting to know each other. For real this time. Not just as musicians, but as mothers ... as women. Women catching up on the glorious (and oftentimes inglorious) rhythms of motherhood, pregnancies, relationships, and the everyday ins and outs of this odd journey we sometimes call "Creative Living."

I am more like a farmer when it comes to creating. I have to let the ground lay fallow for a season before inspiration for more music can begin to sprout up anew. Now Jill ... Jill seems to be different in this way. In the years we walked on campus together, I'd spy the twinkle in her eye that always seemed to signal she was up to something creative. Music, collaborations, playing shows seemed to be the manna along her way.

But I had no idea what a desert walk she was truly on, or how exactly she was turning it into a musical oasis. That is, until I heard and read her latest project, *Thirties*. What Jill has created here is vulnerable, human, raw, and brave. Her songs distill these complex experiences, while being simultaneously unique and common, and the companion writing in *Thirties: The Album in Portrait and Prose* draws out the color even further. Relationships, loss, addiction, restoration—there is beauty in the chaos of it all somehow. Jill plays with the elements of turning pain into clarity, tenderness from being shattered, loss into strength, and reminds us—in music and word—that it's okay to be broken and in process. That the winding path itself is where the beauty begins.

–Joy Williams

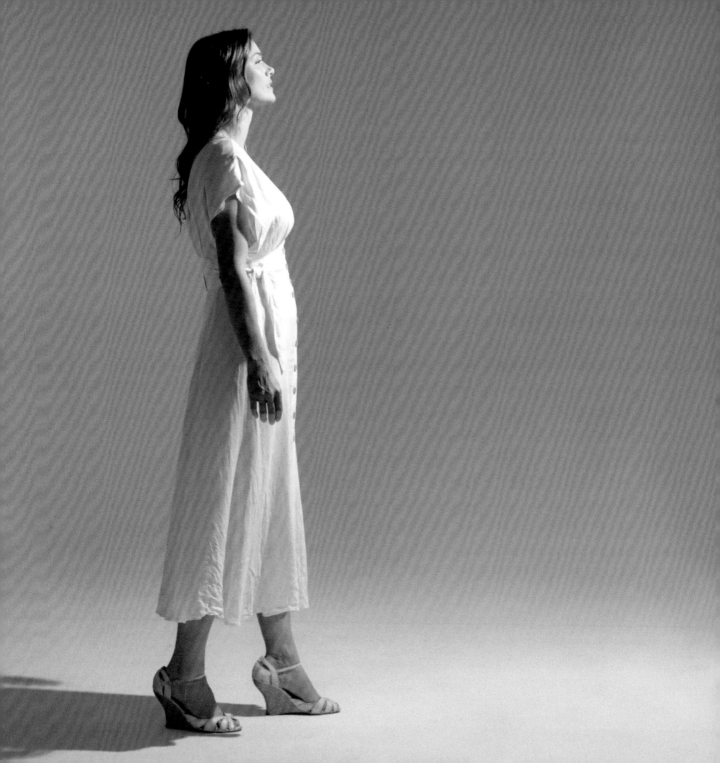

Preface

My eyes open hesitantly on a new day, sleep crusted and stuck. It isn't the sun streaming through my window or a full night's rest that has awakened me. From where I lie, on my half of the bed, it's still and dark in the house. On the other side of my paper-thin door, I hear the baby quietly whining in the next room. Her voice is raspy from last night's crying. I rise immediately, afraid that she will wake my son, who sleeps lightly like his mama. I thrust myself into the upright position; my head is cloudy, and my legs sway like branches in a warm steady breeze. My gaze falls upon my daughter's father. He lies in our bed, breathing heavy. His dark eyes hide within the warm wet comfort of their lids. His arms are splayed across the sheets onto my half of the bed, like he thinks I'm still there. He'll lie there like that for hours to come.

I thought my thirties would be different. I always thought at this age, people had it together: a stable relationship, a steady day job, and a real sense of who they are. I thought I would have it together. My thirties have been spent single parenting, falling in and out of love, wrestling with voices from the past, and struggling with the idea of the future. They have been full of change and growth, deep love and profound loss. They have been humbling and utterly human. They have given me a story to tell.

In the first years of this transformative decade, I started writing a very personal album. It contained thirteen songs about my life, some of the most intimate I'd ever written. As I finished recording it, something about the project felt incomplete: I had more to say, and I wanted to go deeper

than a three-minute song could take me. I wanted to really invite the listener into my world in hopes that in it, they might see a little bit of their own.

These stories are not all wild or awe-inspiring. Many moments may feel quiet and everyday, but I believe that in moments like those, where our minds drift and our hearts ache, deepest truths can be found. Each of the thirteen songs on the record have accompanying photos and a vignette to bring you to the place of its origin. It is my hope that as you read this, you are able to find beauty and value in parts of your own life that you may not have expected. Thank you for reading my first book. These are my thirties.

Jill Andrews

Jill Andrews
August 14, 2019

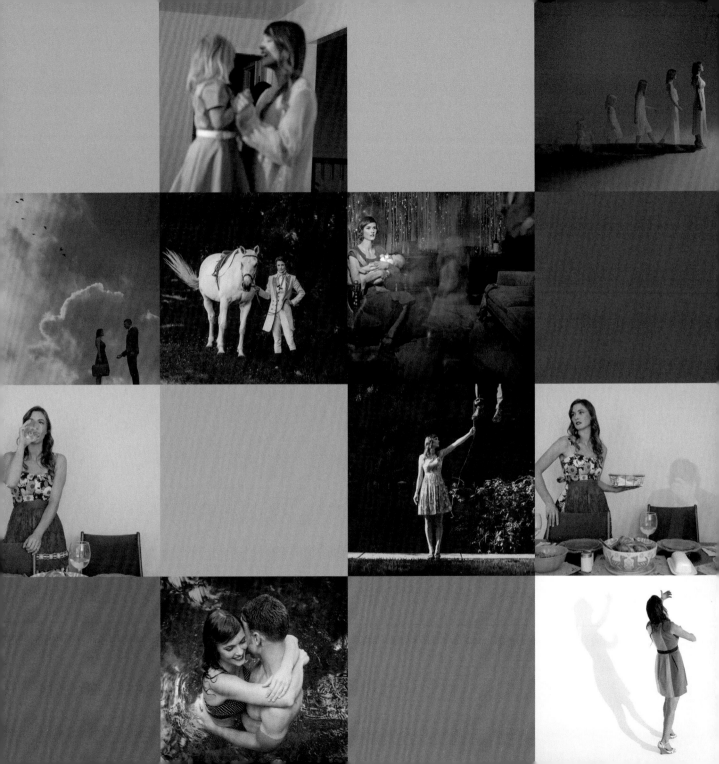

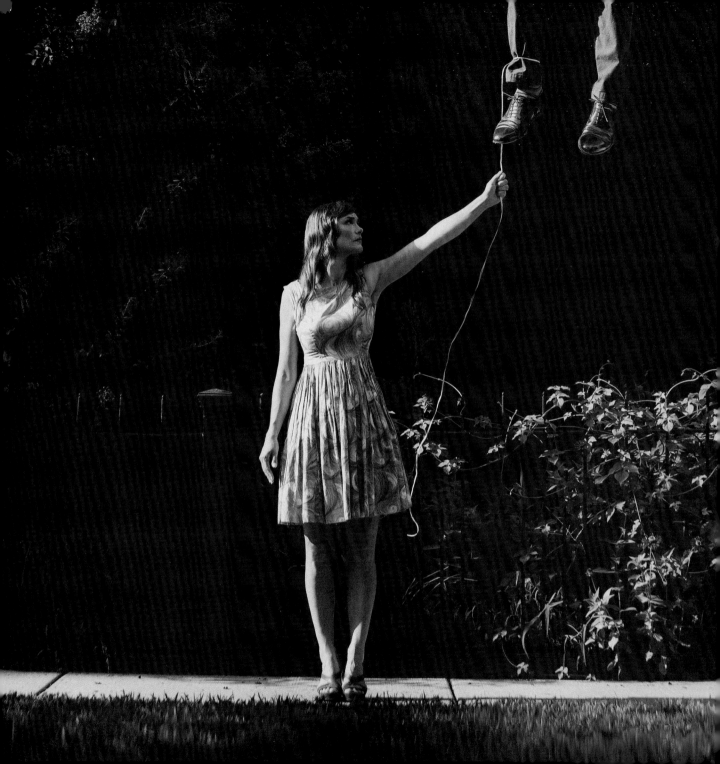

Sorry Now

He sleeps when it's bright and beautiful outside, long after the baby's first morning cry for milk. After the coffee has been drunk, the pot turned off, and the dark sludgy liquid gone bitter from sitting on the burner too long. After the eggs have been cooked and the pans washed and dried. After the misshapen cheese sandwiches have frantically found their way onto plates, apologetically labeled as lunch once again. Block towers have risen and fallen. The precise tiptoeing of morning is traded for the heavy-footed afternoon stampede. The sun sits high in the sky and still, he sleeps.

It's like he's not here, but he is. Truthfully these days, I've been wishing that he wasn't. We are like estranged roommates. I pass him in the hall on the way to the bathroom. I clean up after him.

We don't say much anymore. Life is busy with two children, and most days, the energy stores in me that are allotted to romance get used up slapping together peanut butter and jellies and cleaning up globs of goopy green toothpaste off the mirror. He and I were in love once. It feels like a million years ago now. And some days, I feel like I'm a million years old.

I was in my early thirties when we met; I was still healing from the demise of a very painful marriage—a marriage that never stood a chance. My ex had anger issues and I was a people pleaser. He was prideful and I lacked confidence. We made a son together, equal parts my ex and I, beautiful, buoyant, and full of questions about the world, but quickly it became obvious that I would be both Mother and Father. I would be backyard baseball

coach, head chef, director of bedtime/ bathing operations, chief laundress, and breadwinner. I was happy and exhausted. I was devastatingly empty and I was bursting with love. I could do it all myself; the diapers, the pediatrician visits, the housework, and the career. I was proud, but as my son's first steps were taken and scribbled families of two began appearing on the fridge, I wanted so much to have someone do it with me. I wanted a partner.

When I met him, the one who sleeps, I thought I had found one. He was handsome, eager, willing to help raise a boy that wasn't his, and crazy about me. He made me feel like Woman, Lover, and Friend: the roles I thought divorce and motherhood had taken away. I believed in him the way a child believes in a magician, willingly and with wide eyes. Our love made the impossible feel real to me. As quickly as the wonder appeared though, it vanished.

It all changed one day or a collection of days, a moment of time that I can't isolate but am always trying to pluck from our history. He became distant. His eyes seemed to darken, his color faded to ash. He stopped waking with me in the mornings and kissing us before we left. He stopped working at a job he once loved. He started drinking at lunchtime and didn't stop until he laid down at night. His spirit seemed to shrink with every passing day. I didn't know who he was anymore. I still don't.

I stand at our bedroom doorway, staring at the form snuggled tight within the blankets. I'm holding our infant daughter in my capable but weary arms. I don't move any further toward him. This is his territory now. I've stopped going into the bedroom and gently stroking his cheek, whispering in a delicate voice all the hopes that I have for our day. I've stopped imagining us sitting on the couch together, sipping from warm mugs, feet propped up in his lap watching the kids play happily on the floor. I no longer have

hopes of piling one by one into the hot car for a family trip to the park. For the second time in my life, I'm doing it all alone.

It's the afternoon. We go on living without him. I let him sleep now when it's bright and beautiful outside, and I too miss the world out there.

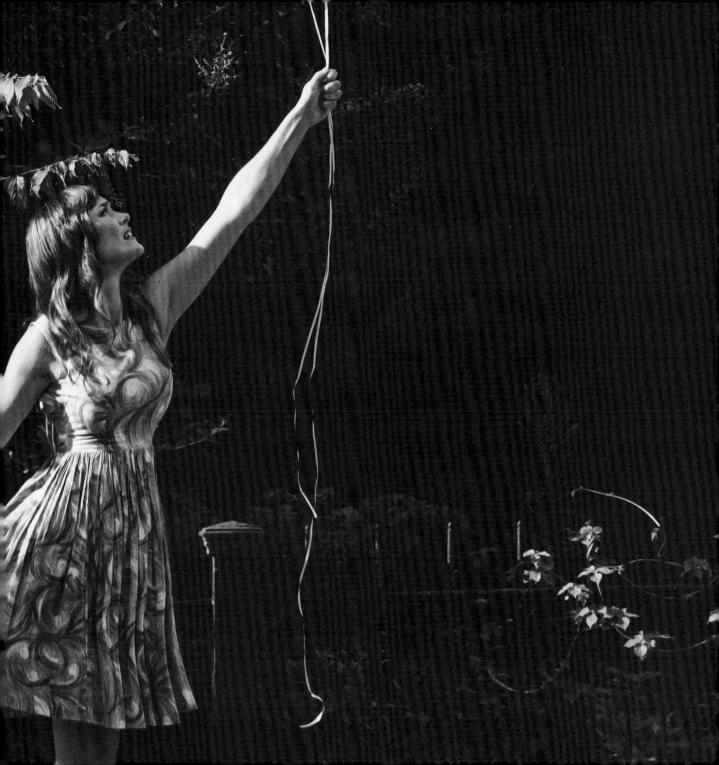

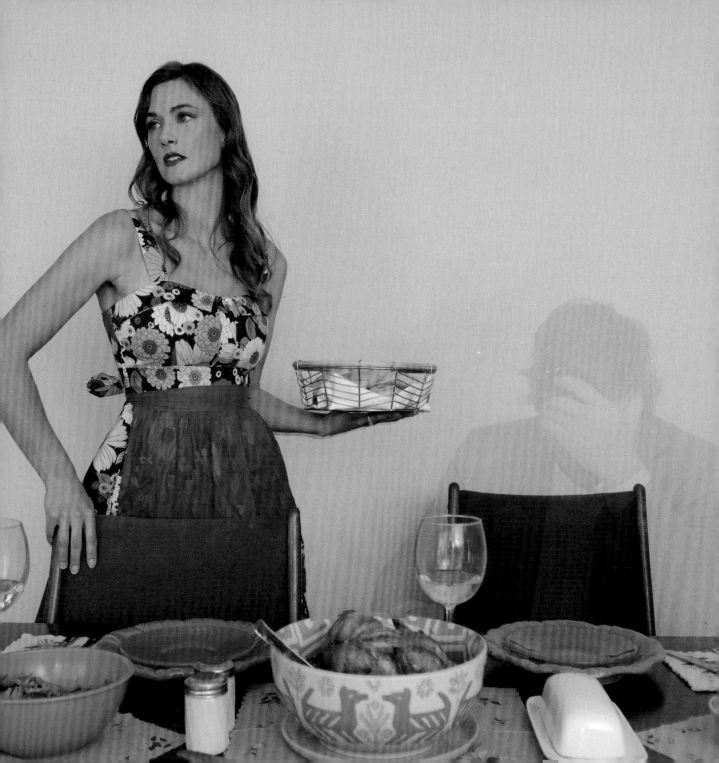

Sold My Heart

I'm standing outside at the top of our long driveway looking northward at the rolling hills in the distance. They look like the mountains that I grew up seeing in East Tennessee, an endless expanse of green covered limestone and shale as far as the eye can see. I'm in Nashville now, a big city with bumper-to-bumper traffic and random violence. This view, the feeling of being far away from all of that, was the reason we bought this house last spring. We thought it would be a good place to raise our family.

It's fall now, the cool air surrounds my body and enters in where it can, down the collar of my coat and up the legs of my jeans. It yearns to be close, to be warmed by my skin, but I'm covered in goosebumps and have little comfort to offer as it swirls around me. I'm alone out here, but I can see the neighbors through the skeletal tree limbs that were once lush. They can see me too. They wave and smile like we're meeting for the first time. I thought I would miss the bright green canopy that blanketed us all summer and held us like a perfect secret, but now, I'm just happy to be seen, acknowledged by another beating heart. They don't wave at him the way they do at me; they're not sure if he lives here or not because he doesn't come out in the daylight long enough for them to learn his face.

I remember falling in love with him. I replay it over and over when the air gets too cold on my skin. I remember the way that he held my son's hand for the first time as they crossed the street in our old neighborhood, carefully and gently on their way to get ice cream. He held

onto him like I'd always hoped his own father would but didn't. There was curious excitement in my three-year-old's eyes when he looked up at the tall tower of a man who promised adventures and BB guns and fishing trips. He was the fun one, before *we* were anything at all, his face perpetually crowded by an enormous toothy smile. I fell fast. I remember buying this house. He talked about building a studio in the basement and giving the kids each their own room. We would have enough space to grow here, he said. We could have a garden and clear out the woods so the kids could go exploring. This was supposed to be our home. I smile when I look over at it, warm and bright, just the right size and just the right light. He promised me adventures too.

A soft, lazy rain begins to fall, and I look around, hungry for the sense of home I once had here. I walk over to the little herb garden that we planted when we moved in, back when he let the sun rest on his skin and laughed at my jokes. I touch the decaying tendrils of basil and cilantro as they hang low to the ground, begging for rest. We were going to pick the bright green leaves with the children and watch their noses wrinkle as they went in for their first taste. We were going to plant rosemary and mint and throw them into bubbling pots on the stove. We were going to do so many things. Now, the stalks are swaybacked and withered. The brown slimy leaves still glisten fantastically with the water from the sky, but they no longer drink. I mourn them a little.

An icy wind picks up. I bend down to get a closer look: the plastic signs from the nursery are sun-bleached and stuck in the places they were first planted. I wonder quietly, *How can so much damage be done in a single growing season?*

Tenderly, as kindly as I can, I grab onto what's left and start pulling up the roots that we planted here.

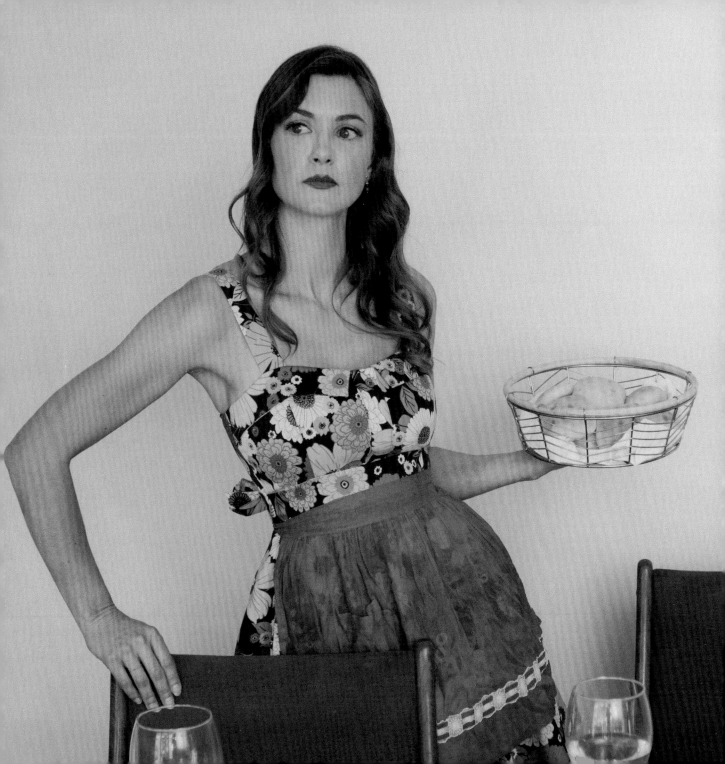

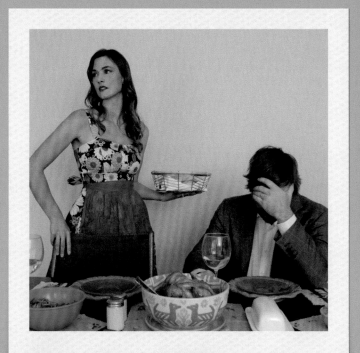

I tell myself the greatest lies

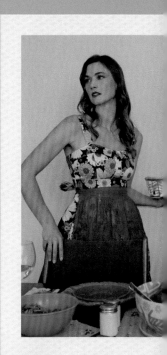

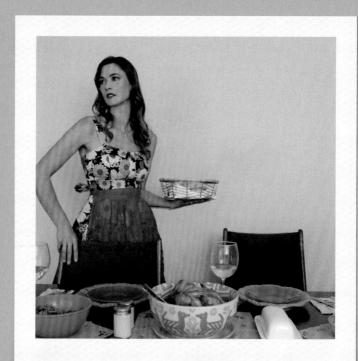

I think I sold my heart out this time

Forces

I walk past the full-length mirror in my bathroom glancing over as I often do. I try to stop myself. I don't want to obsess. I don't want to stare and analyze every new line and spot on my face. Time is elusive but it shows up on me in deepening crevices and creases, and I can't look away.

Today, something glistens and catches my eye. Something new.

Grey.

The kids are calling me from the next room, but I'm too distracted by this new discovery to walk away. I push in even closer towards my reflection and pull back a few pieces of hair to get a better look. It's long and coarse, silver as a nickel. There are a few of them, turning like leaves from brown to a steely...

Grey.

My immediate reaction is neither disgust nor fear, but disbelief. It seems too soon. My parents are both nearing seventy years old, and they just started going grey, a few dashes of salt on the top of my dad's handsome jet-black head and a slight glimmer surrounding my Mom's face that only reveals itself in the sun. I'm only thirty-six. When I think about it though, staring at the new shiny strands, thirty-six sounds awfully close to forty.

I remember going to my Dad's 40th birthday party. It was at one of our neighbor's houses, just down the street. I spent most of the night at the food table blobbing sour cream onto my baked potato and trying to be polite. Black balloons lazily floated around the living room with the words "Over the Hill" printed across their bellies. I nudged them

with my fingers as I waded through a sea of smiling middle-aged faces, flushed like the rosé in their glasses. I was bored and I was confused.

My Dad didn't seem any different to me that day than he did the day before but people were teasing him and laughing. Normally, he was the one dishing it out. They clinked glasses with him and slapped him on the back. They brought gag gifts and made jokes about AARP. I didn't understand what was so special about this year or why we couldn't have just bought him his favorite coconut cake from the freezer section at the grocery store and sang "Happy Birthday" around the table at home. Everyone else in the room seemed to understand. It felt like he was losing something, and I was the only one who couldn't see what it was. I see it now on my own head. We aren't in control and we aren't permanent here. Balloons or not, time never forgets to remind us of its passing.

The memory is jarring. I feel panic rise up in my throat, and I lower my body onto the toilet lid to think.

I'm not the only one in this house with newly found grey hair. He has it too, just on the other side of this wall. It sits in the bristles of his beard and on the top of his head. It sternly advises him to let go of childhood, of 2 am, and that last beer. It reminds him to care for himself, to care for us, to settle in and forge ahead. It reminds me that I don't have forever and of every countless moment I've wasted waiting on him to change. I think about our love, the way it's aged, grown frail, and withered from neglect. The tie between us groans as we pull away from each other, straining more every day, with each growing grey. Thoughts spiral and my heart beats like it's driven by amphetamines.

How did I end up here?

It seems simple. We were easy to believe in. I believed him when he said he would stay home, get up, stop drinking,

and be there for us. I believed that our love would grow stronger year by year as we watched the kids grow up and move out. I believed that we would love each other far beyond our thirties and that only death would someday break us apart. I believed that my heart was strong enough to handle his crippling hurt amidst my own.

I stand up and look at myself in the mirror again, still studying the newly found strands of grey on my head. I've spent years believing in him. It's time to start believing in myself. I bring my face in close to the mirror to examine the woman staring back at me. Her strength doesn't wither or wane.

The sharp lines at the corner of her eyes were carved in the search for wisdom, the creases on her forehead were formed in the red-hot flames of determination. The valleys on either side of her lips were molded by rivers of deep emotion. She can choose to proudly wear every change a new year brings, no longer seeing just the time that's gone, but the value of the time before her. The choice is hers.

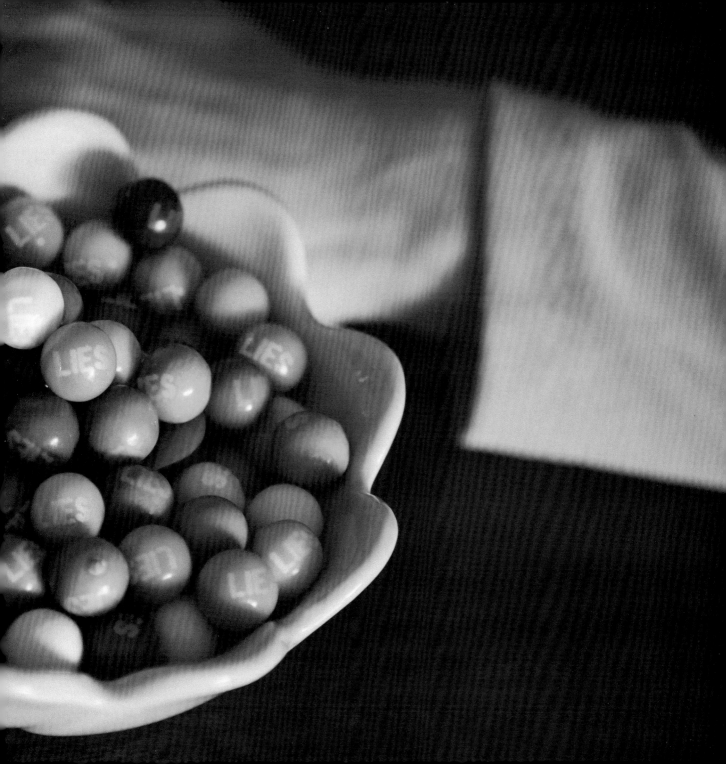

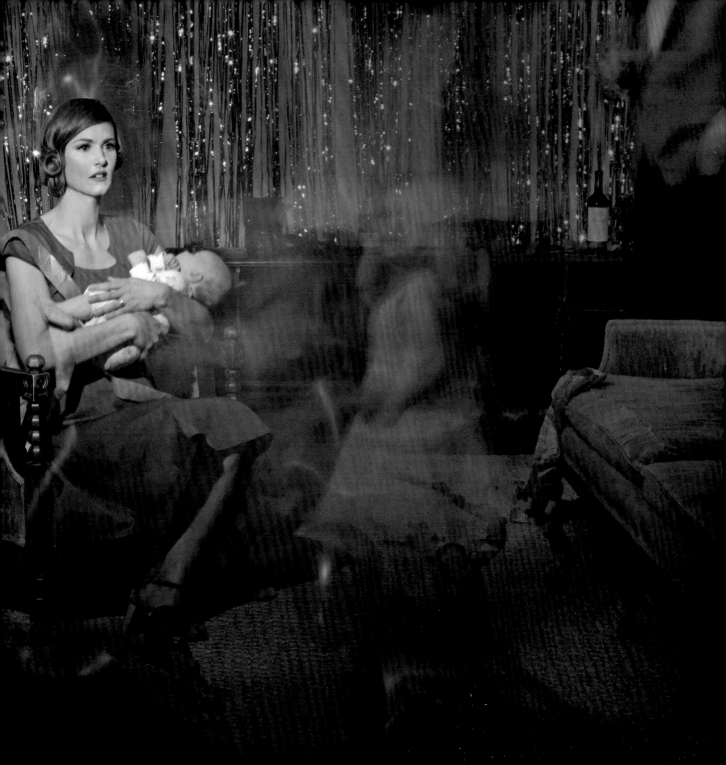

The Party

It's the middle of the night, but I tell myself the sun will be coming up soon. It makes me feel less alone to think this way. The mapled tree line of our property calls to me as I stare out the window waiting for a sign of life, for another solitary night creature to meet my eyes with its own. My ears wait too, starved for the early morning cry of a lawn mower, a barking dog, anything to make the quiet feel less like loneliness. I wait for a connection.

The baby is in my arms. She is the reason I'm awake. At just six months old, she's a stranger to time but she seems to like the hours when the sky is too blue to be night and too black to be morning the best. All she knows is hunger, the burning and twisting in her belly. She is its host much like I was hers for those long nine months. I look down at her face at the incarnation of my blue eyes, and I also feel the burning and twisting. I hunger for sleep and freedom for my body, and also for him. I wonder when he'll be home, I keep waiting for my connection.

The sun is still deciding what to do when she finishes eating: the horizon glows hesitantly, not wanting to commit to the day just yet. I watch her eyelids flutter slowly *on/off, on/off* to a closed position and feel her melt into me. Sometimes I hold her here for a while, hoping that he'll come through the door in time to witness the constant miracle she is, small and pink, brand new and helpless, ours. She lies underbelly up, vulnerable to all the vicious predators of the world, blindly trusting that my tired arms will protect her. I sit and take her in, silently hoping that they can. He was supposed to be home hours

ago. This silent space was supposed to belong to both of us.

I let my mind drift and find myself in a place that feels miles from the quiet of this room. The lights are dim. There is a boozy smell in the air. Friends are laughing and music is playing on the stereo. I see him, cracking jokes with a drink in his hand. His face is delighted and his responsibilities are few. He's forgotten about us and found the people he was looking for, the ones that don't ask him for anything, the ones that smile and move on to the next person without any fuss. The people that don't know what he's like when he's too tired to wake up in the morning and too tired still in the afternoon. They don't know what it is to worry about him, to try and be there for him without fading away from yourself.

He turns the music up, cracks open another beer, and basks in it all. I long to be there with him, but I resent the fact that he's there. I know the pain that his jokes are trying hard to mask. I don't know how to love him anymore. I'm confused and exhausted. The brighter he shines in those dimly lit spaces, the less he lights up around here.

The baby suddenly jumps in my arms, and I'm jolted back to her. I leave him in my imagination, to find himself or who he thinks he is in that crowded room. He's alive in the party, the life of it, and the party never stops calling his name. It calls so loudly that he can hardly hear my voice anymore.

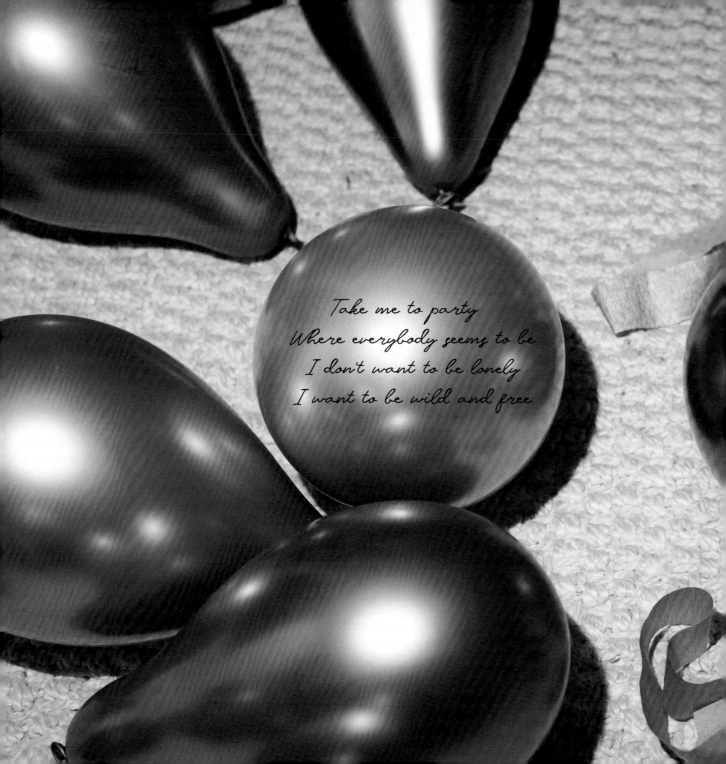

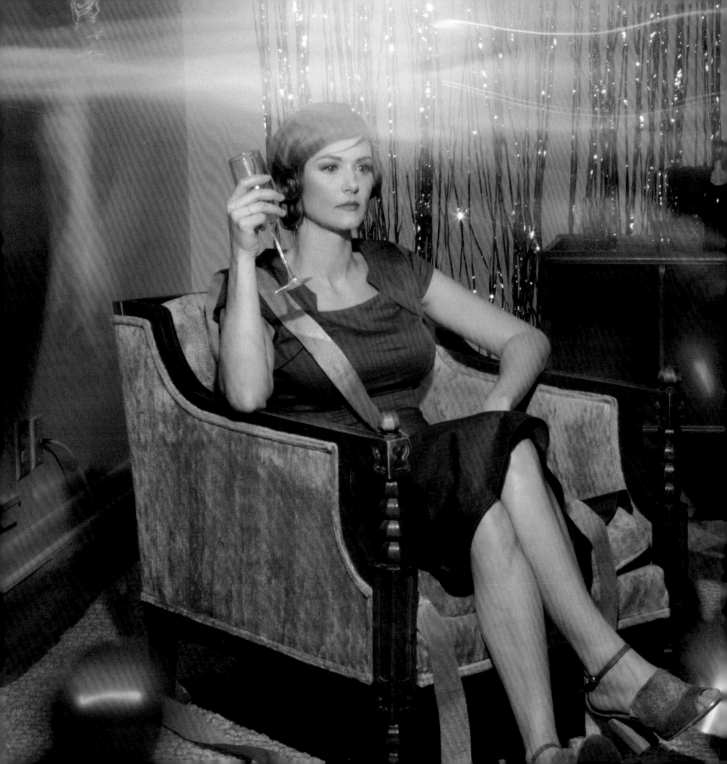

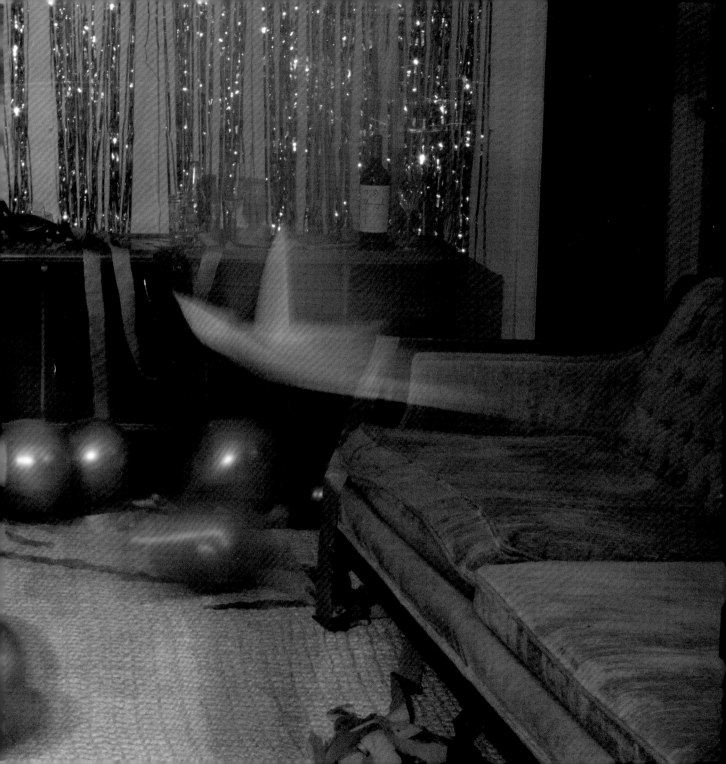

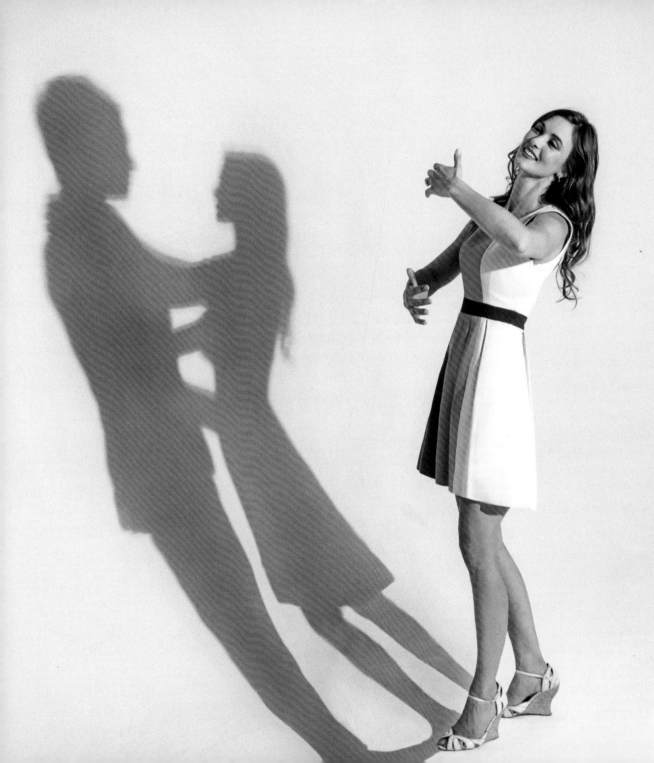

Gimme The Beat Back

My closet is a mess. I'm looking for something to wear but I haven't figured out what yet. I peel back hangers holding tight to dresses, dresses I haven't worn in so long I wonder if they still fit one year after giving birth. My body is recovering but I'm a different shape now, and I'm unsure if I'll ever be the shape I was again—curvy in most of the right places. I run my fingers across the swaths of fabric one by one and take note of the feel of them on my skin. Each garment that hangs there has its own unique set of memories sunk deep into the seams.

There is a dress crumpled up on the floor at my feet. It almost made it into the clothes hamper but didn't. That always feels a little too final. It's lying beside the hamper instead, too dirty for the hanger and too clean for the washing machine.

This dress is special, more so than the others. It's lightweight and colorful with turquoise and burnt orange spread from shin to shoulder in wildly different but complementary geometric figures. It hugs my body the way a dress should, and it doesn't wrinkle. I've worn it to concerts and I've worn it to clean my toilets. It's excellent attire for both. If anything has seen my thirties, lived through them with me, it has been this dress.

When I bought it, I was still living in Knoxville. I had an apartment in the southern part of the city, just across the Tennessee River from downtown. It was an old white house that had been separated long ago into two apartments. Inside was an out-of-tune thrift store piano that I asked two of my friends to haul across town and deliver into my living room.

I remember watching them in my new dress, directing them through the door, wondering if I could teach myself to read music and play it properly. The cold of the bench came all the way through the thin fabric the first time I sat down to try. I wore it everywhere from the dentist's office to the dog park. I wore it so much that the blindingly bright colors started to fade after a month. I still liked it anyway.

As time went on, it became a good friend to me. It clung to my body the day that I gave birth to my son, witnessing my strength from the back of a hospital chair as my body writhed and contorted in pain. I'd been reluctant to pull it off and sling it there, trading it in slowly for a bristly blue gown.

It protected me like armor a few months later when my new baby's father flipped over our coffee table, spilling wine and breaking glass all around us. It held me as I sat crumpled up on the floor, surrounded by shards of sticky red glass, crying so hard that no sound came out.

It stood up tall with me, billowing at my knees when I decided to leave and took my first few shaky steps as a single mom.

I was wearing it the day I turned thirty-one, and my friends took me out to my favorite bar as a surprise. I was newly divorced, I had a one-year-old, and they thought I needed to live it up.

They didn't want me to know where we were going, so they put a white paper bag over my head, stuffed me and my beloved comfy dress into the backseat of one of their cars, and drove me downtown to my favorite bar to go dancing. I didn't know where we were until they put a drink in my hand, lifted the bag off my eyes, and pulled me out onto the dance floor. We moved together like fingers on the same hand, smiles plastered on our faces, twisting, turning, and bouncing off of each other. I spilled my Miller High Life all over

my best friend's shoe as we dipped and swayed and laughed hysterically. He answered back by pouring his very full beer all over my well-worn and well-loved dress. I couldn't have cared less. I can't remember the last time I felt that way.

In my closet, I bend down and gather up my beloved pile of fabric from the floor. I bring it close to my face and breathe in deeply, the smell of cheap beer and best friends is no longer present. I hoped it would stay forever, but like the laughter from that night, it has faded. What remains is a garment, sour from the leaking breastmilk of a newly-made mother for the second time, and the mother, standing silently in her closet, holding onto her past as tightly as she holds onto an old worn-out dress.

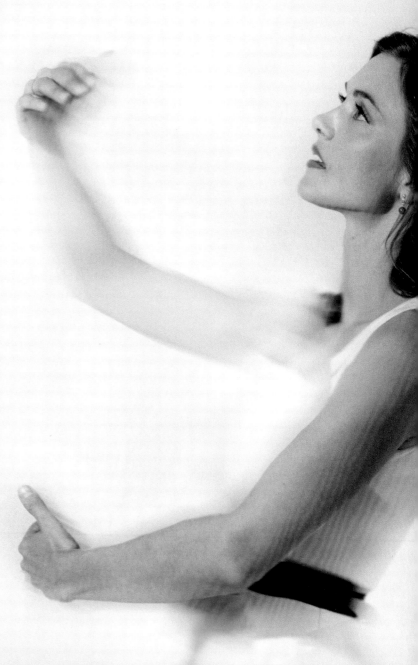

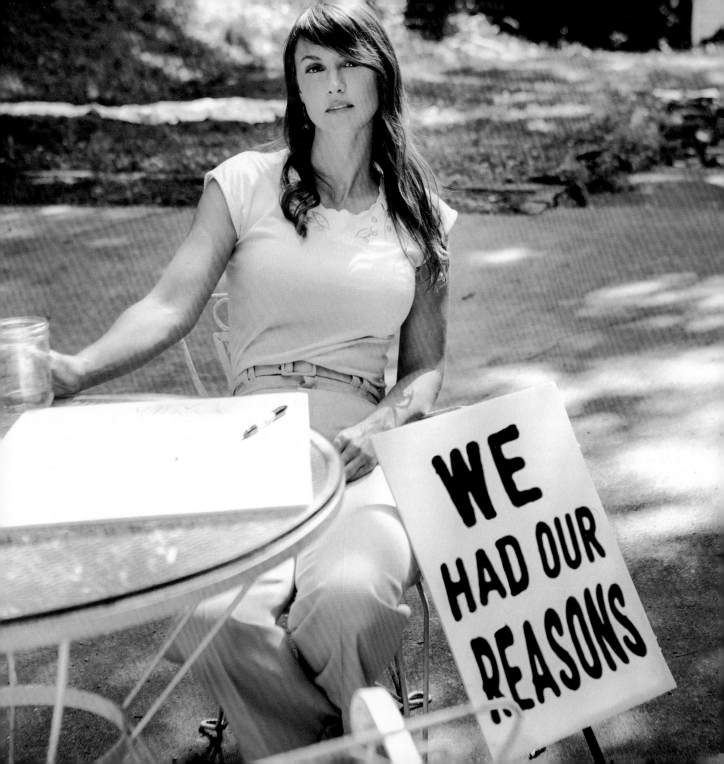

Call It Even

He turns to me as we lay in bed, rolling over on his side, tilting his face towards mine. He wants something from me. I can feel it.

Today is Thanksgiving. We spent the afternoon hanging out with my family, eating too much pie and chasing the kids, ages seven and one, around the leaf and walnut covered yard. He was on his phone a lot, head down, swiping furiously like he was directing traffic with his index finger. To the people around us, it was just another day, another pre-fab Thanksgiving with parade floats on TV and a turkey in the oven. We looked like we always did. We wore faces that wouldn't raise any alarms, happy enough to keep the kids and grandparents from wondering about us. I'd force a laugh out now and then; he'd place a mechanical hand on my knee.

We'd call each other "babe."

Things look different at home though. My smiles here are simply polite—an obligatory opening of the mouth and a small showing of teeth. There's no laughter waiting at the back of my throat, and no faking it. The laugh I've been known for all of my life, the one where I lose control of my limbs and end up falling on the person next to me, hasn't rung out in ages. All I can taste is worry and resentment. It sticks to my tongue like Velcro. The conversation is forced and the motions of our day, robotic.

He reaches for me—breath sour with pale ale and American Spirits, familiar smells that I've grown to hate and blame for what happened to him: the depression, the disappointment, the progressive fade from man to ghost. He wants to pull me

close, for me to want him, but I don't anymore. I don't know what I want. Every decision has consequences and I'm already feeling the effects of the ones I've made.

There is someone else here with us tonight. I've been wondering lately if she would come. I have felt her running alongside me for some time now, trying to keep up with the reckless pace I've set in life, tapping me on the shoulder like an annoying younger sibling, crowding my ears with her opinions and questions:

What is your plan?

How long will you keep doing this?

Is this really what you want?

She has watched me for years struggling to navigate this perilous relationship. She has been patient. She has let me steer the vessel and now it's stuck in the sand, caught between jagged rocks. It's taking on more water the longer I cling to the wheel and the harder I try to puff up the sails with my tired breath. I have been good at ignoring her. I didn't want to hear what she had to say. I wanted to change things that were impossible to change. For just a moment, I let my guard down. I take my hands off the wheel, and I listen.

No, her gentle voice urges in my head. *You deserve better than this.*

Something slams shut inside of me, breaking and battering everything in its path as it crashes to a close. Memories and desires lie strewn around in fragments— limbless, bloody, lifeless old dreams. He is there in the wreckage but he's unrecognizable to me. He's like a stranger though he hasn't really changed at all. I have.

It's over after four years. I'm resolute. No promise could restore what is now gone forever. No plea can reach my ears. I am impenetrable to tears and negotiations.

I hear her voice again. I know what she's going to say before she says it.

It's time. It's your time now. Go on, she assures me.

His hand begins tracing the curve of my neck. I roll over onto my side, turning away from him, and her words, my words finally come out.

"No," I say. "I can't do this anymore."

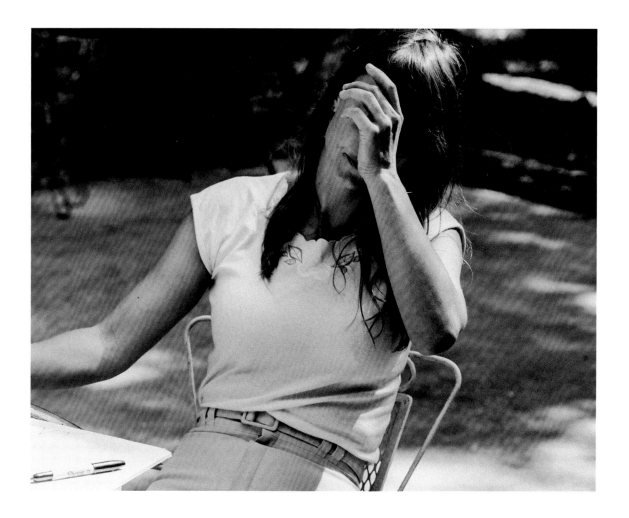

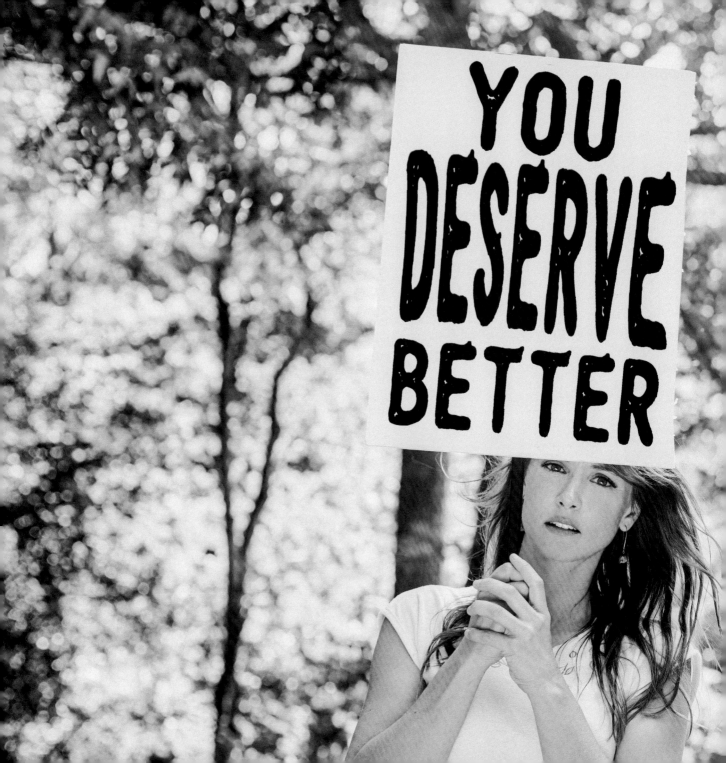

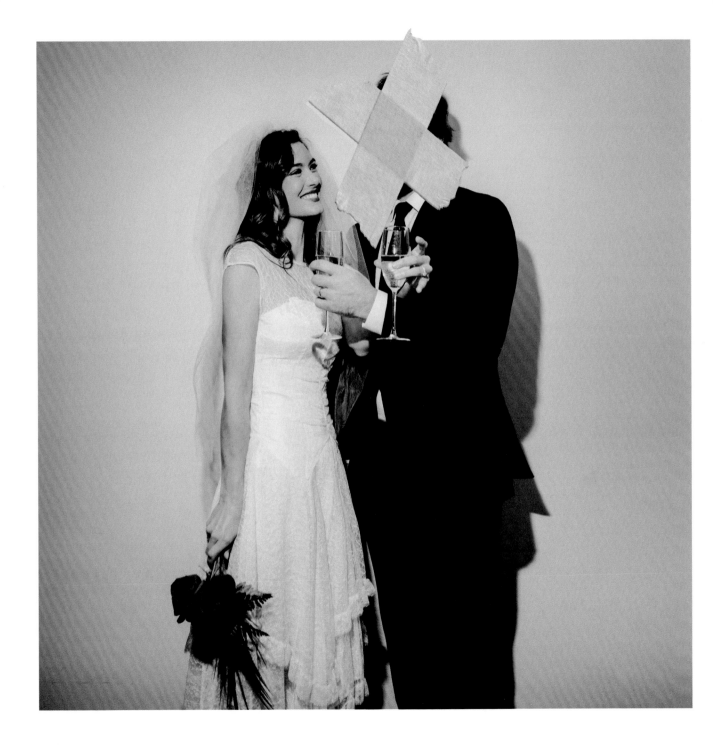

Back Together

Today was a blur, much like the days that preceded it, and most likely the days that will follow. He's been gone one month. I'm alone and I'm tired. I've been white knuckling it from 6 am to 9 pm.

I don't miss him. It's the routine that gets me—not the isolation but the monotony—the hard physical and spiritual work of parenting alone. My body hurts at the end of the day, and my brain is fried. In the evening baths are given, stories read, prayers spoken, lights turned off, then turned back on and chased by the music of little feet running frantically down the hallway. Tears are wiped, hugs are given, bad dreams erased, good dreams inspired. The dinner dishes are rinsed and dried, the school lunches are made, the wine is opened, poured, and consumed. Over and over, every day it stings and it numbs.

I have edges now, edges forged in the pressure, the loneliness, the aloneness, and the intensity of it all. I wear them proudly like a medal of honor.

The kids are in bed. Everything is quiet. I look around at the space that he left from my new seat in the middle of the sofa, glass of wine in hand. The house feels different now, not emptier but bigger maybe. The echoes are longer and louder, shooting down the hallway, bouncing from wall to wall, and trailing off in our bedroom, my bedroom now. The air is clearer without the resentment flying around like a flock of shitting gulls. I like who I am in this new space: confident, unflinching, and tough. I depend on myself now, and I know exactly what to expect. I'm becoming a good partner to myself: I'm forgiving and I'm fair. I work hard at this relationship. I have

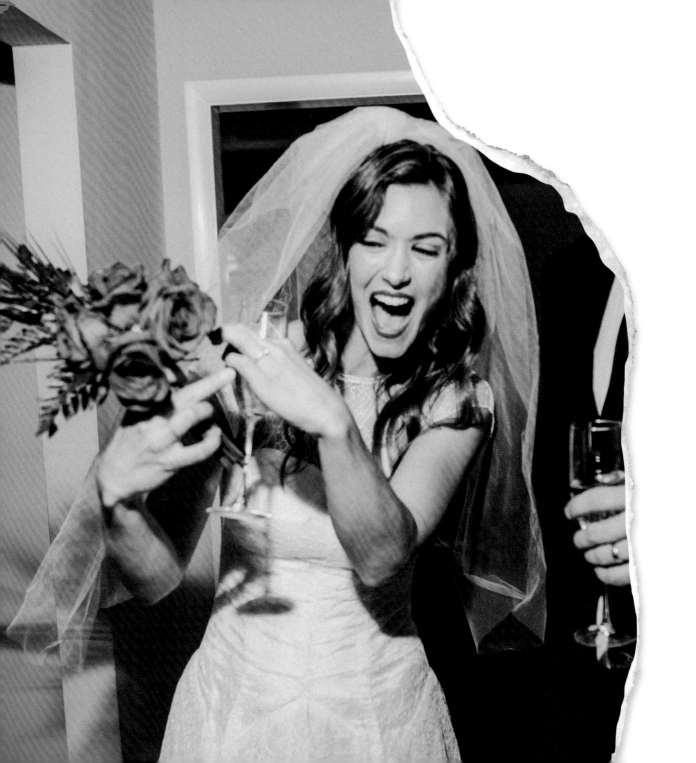

a sense of control, as much control as one can have hanging out with two little people who randomly throw mac and cheese at each other.

There is life within these walls, a life that I'm building with my hands and heart. I didn't know this place could be home without him in it, but it looks good and it feels good. I reclaim the negative space by shoving tropical green leafy botanicals of all sizes into every naked corner. I rearrange the furniture and put up new artwork. I buy blankets and vases and fill them with brightly colored flowers. I've started buying my own flowers, and I like it that way. I make things exactly how I want them to be, positioning the vases in various spots around the house and staring at them from different vantage points, tilting my head *almost* and reconfiguring. I could deal with the space

that he left by drugging or clubbing but instead I mainline indoor vegetation. It makes me feel like a jungle princess and supposedly helps us all breathe better anyways. I don't know if I've ever breathed so well before, so freely.

My kids' sticky strawberry-jellied fingers grasp onto mine as we examine our new space together. They watch me struggle and soar. They help me decide where the fern should go and fight over who gets to water it. They're proud of my edges too.

I look around the room, exhausted and exhilarated.

"One month," I say to it.

I take a long, warm drink of my wine, and I get up. I decide to move the orange vase with the daisies, because I can. Because this space and every beautiful edge inside of it belongs to me.

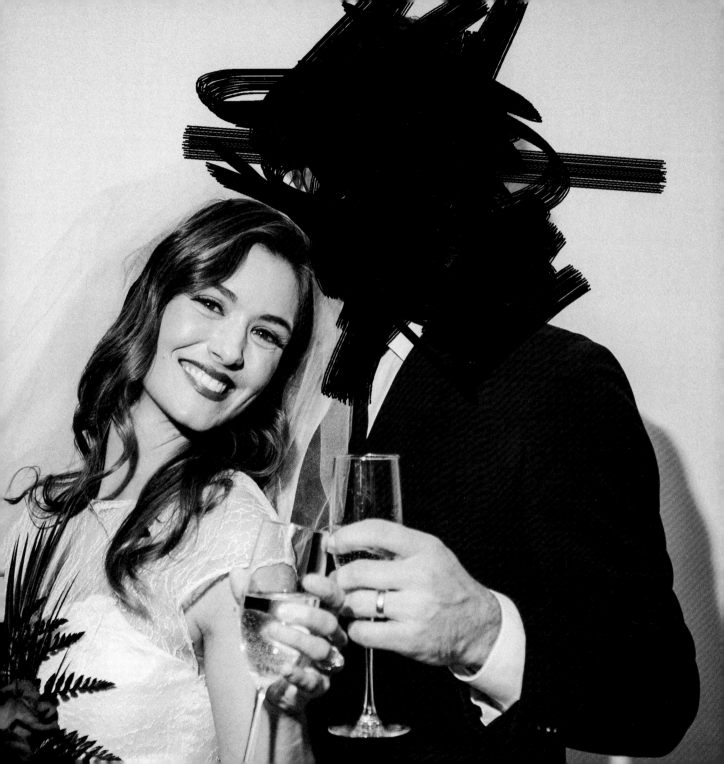

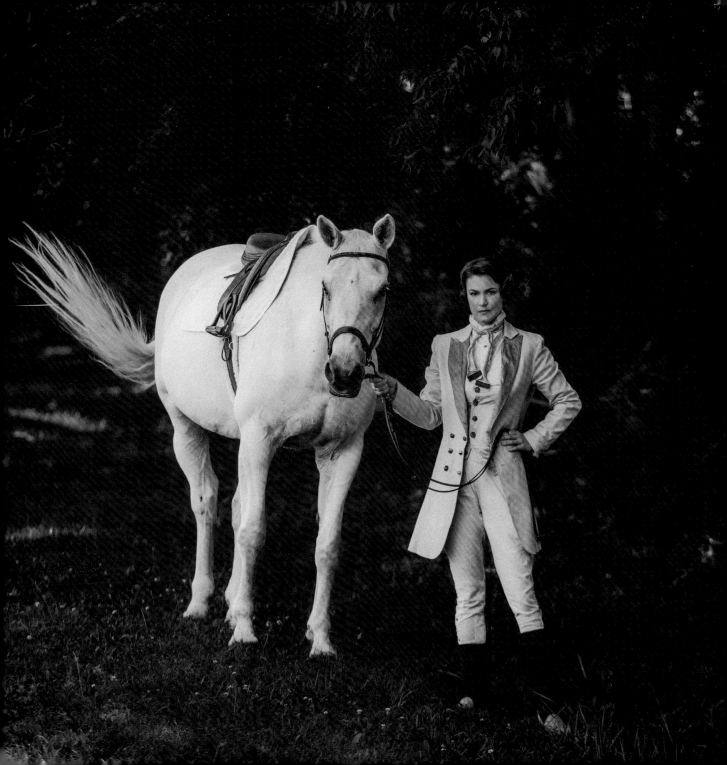

My Own Way

The little plastic dinosaurs are everywhere. I walk through the living room gathering them up and tossing them into a large wicker basket, full of bits and pieces I don't even remember buying. I'm nearly finished. The kids normally help with cleanup, but it was late when we got home tonight, so I rushed them off to bed, each with a story and a kiss. I spot my daughter's princess doll lying just underneath the couch, tall slender legs pointed toward me. I gather her up in my arms and hold her for a second. Her hair is matted and there are small bits of leaves in it, one too many trips outdoors for this member of the royal family. I run my hand over her strange, synthetic mane. A comb would probably break before it would wrestle the knots out of her head. She looks terrible, but her perfectly plastic lips still manage to hold a smile on her perfectly symmetrical plastic face. Inspecting her like an artifact, I hold her up to the light and wonder what this beautiful, slender, happy princess, all draped in a pastel silky gown, is teaching my eighteen-month-old daughter.

If this foot-long plastic doll came to life and set out to survive in the world, I wonder if she'd still be smiling. What would she think of herself? Would she value her own strengths and talents? Would she recognize her beauty as a gift, or would she dislike the feeling of being a trophy? Would she love herself when her beauty went to hell? Or would she hate herself into every new year? Just how long would she sit back in her velvet chair waiting for Prince Charming? I put the doll into the basket, the basket into the closet, pajamas onto my body, and I

sit down to think. I remember when the doubt started to sneak in, when I first felt the emotional cargo of womanhood settle onto my shoulders.

I was in seventh grade. I was writing my name (probably next to a boy's) in bubble letters, carefully twisting and turning the magenta around the cobalt blue to form a perfect "L." I heard giggling. I looked up from my colorful paper.

"Hey Jill, you got boobs over the summer!"

My heart sank, but I kept my composure. I laughed it off like my body was a joke. That's what you do in middle school when a young woman's worth is calculated by the brand of her jeans and how much aerosol spray her poufy bangs can contain. You play it cool.

The shape had come quickly, almost overnight, and I wished I could reverse it immediately. A bra quietly appeared in my underwear drawer. Maxi pads the size of canoes quietly appeared under the bathroom sink. And quietest of all, I accepted the inevitability that I was now part of a different world, a world that had been spelled out matter-of-factly everywhere from the fairytales that I read in second grade to the ads in the back of my mom's *Family Circle.* One day, the messages said, your body will be more important than the soul it contains. One day, you stop being your own person and you become somebody else's prize.

I briefly tried to combat the inevitability of womanhood. I wore baggy clothes from my Dad's closet because I thought they would protect me from the catcalls on the street and unsolicited quips of the little dumbasses in the hallway. But eventually, after a couple of years of hiding within the dress code of the grunge movement, I decided to show myself. At nineteen years old, I stood on a stage behind a guitar and defiantly sang louder than the fairy tales, the TV shows, and the men on the street. At twenty-nine, I carried a child.

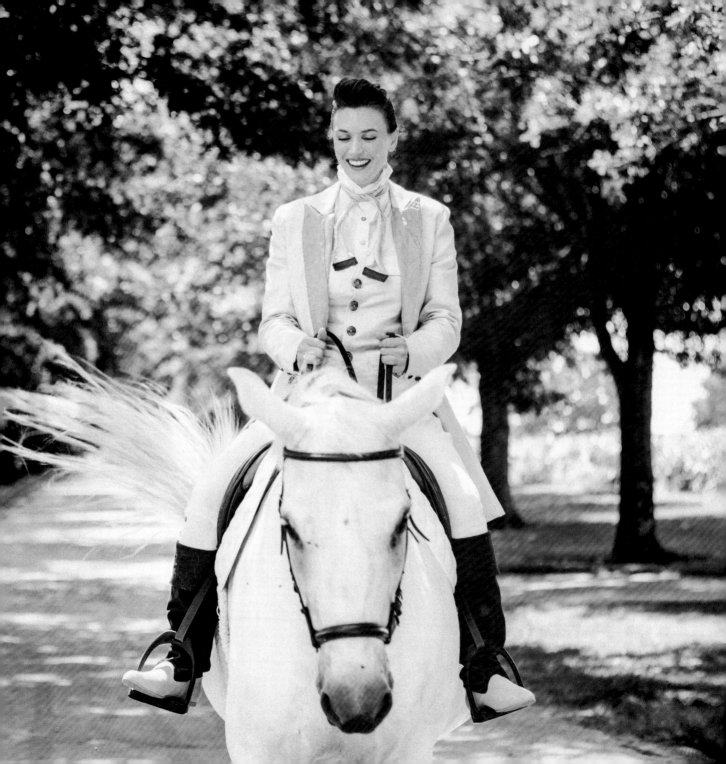

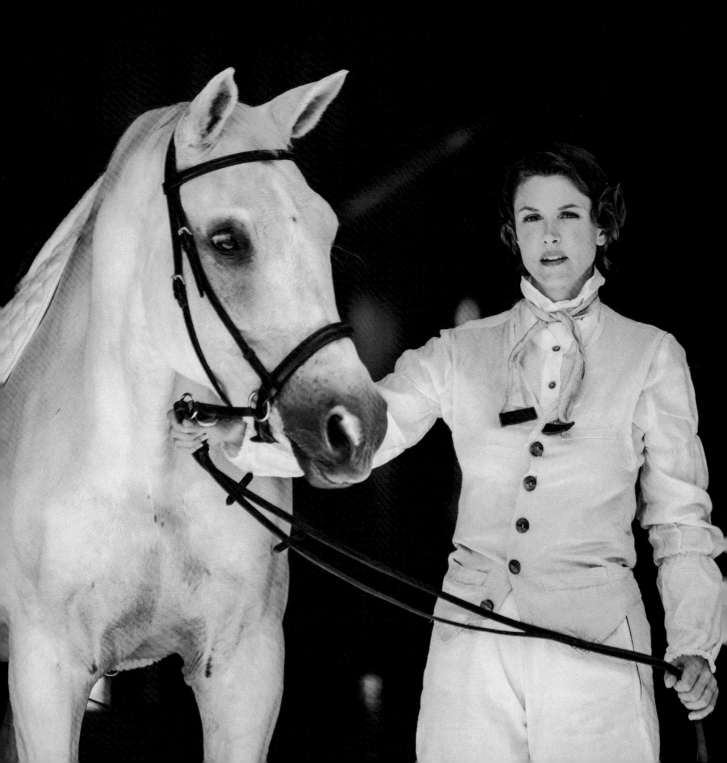

I protected him and nourished him, pushed him screaming into existence. I'm not a princess, and my body is not a trophy. It's a tool, incredible because of the spirit and strength that it contains.

I hear my daughter stirring in the next room. I go and peek through the crack in her door. She is crying for me and calling for milk. I lift her out of her crib and into my arms. I rock her and think of the lost little princess in the wicker basket. I wonder what lessons I am teaching my daughter. Sometimes I tell her that she is beautiful, but mostly I tell her how strong, smart, and capable she is. That's what I always needed to hear.

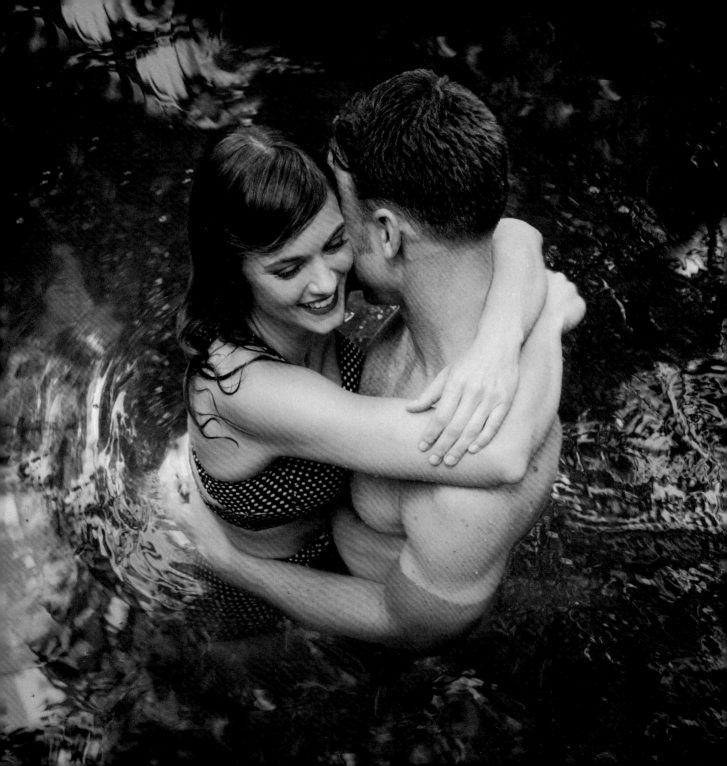

River Swimming

I'm standing at the end of a wooden dock. Someone who I've never met is holding me tightly, his arms wrapped around my waist. I can't see his face. It's pressed up against mine in a deep loving kiss. The wind is crisp and gentle as it climbs over us. The waves are easy: they crawl beneath us, forcing us into an accidental but welcome slow dance.

As we stand there, I can feel how valuable I am to him, how beautiful I am in his eyes. His touch radiates a kind of love that I've never known. It's not a passing feeling; its depths are profound, a little mysterious even. I'm something he's imagined but never seen, something he's hoped for but never believed possible. My flaws and brokenness don't sway him, the uncertainty of the future doesn't scare him. He is devoted to me and I, to him.

Standing there, wrapped up in each other, bathed in sunlight and river music, we are equals. We need nothing from each other and want everything because of it.

This is a dream, an unexplainable vision that came to me one night sometime between dark and dawn. I normally forget my dreams, dismiss them even, but this one lingers. It makes me believe that love like this can exist for me, that it waits somewhere on an unknown riverbank.

I am single now. I have been for six months and for the most part, I'm settled in it. I have met interesting people but nobody I have felt drawn to, nobody who can compete with the faceless man at the end of the dock. Life is busy, too busy for dreams. I tell myself that I don't have time for love, that I need to wake up and stop expecting to find him out there. I try to

forget the man and the dock and the way it feels, but I can't. Day after day, he stays with me.

The second the sun peeks out over the horizon, my children's eyes burst open and they sprint from their beds looking for eggs, cereal, and milk.

"Mama, where are my shoes?" "Mama, can I play with my friend today?" "Mama, can we go to the playground?"

I smile.

I picture him scooping them up while I make breakfast, one under each arm, making them giggle until their cheeks go pink. As I burrow tunnels through hills of laundry and mountains of bills, I roll my eyes and imagine him folding the wash cloths and balancing the checkbook with me. I let the dream keep me company, make me the promise of the life I stopped trusting in years ago.

When I look in the mirror at the end of the day, exhausted, color drained from my cheeks, I feel him beholding me, reminding me that I am beautiful. When my children have nightmares, I feel him sitting next to me on the bed shushing them to sleep as his own. When my heart remembers how badly it broke, I feel him holding it, holding me tenderly. I let the thought of him carry me from despair to peace and even though I know it's just a thought, thoughts can be powerful. They can change you.

After the kids are in bed and the chores are all done for the day, I settle down to sleep. I close my eyes and meet him on the edge of the swaying pier. We dance together just like we did the very first time he came to me. I stand there in his arms, covered up in his love, and I give in to the moment with a sense of knowing. There is great and fantastic love charging towards me from some unknown direction, I am deserving of it, I am ready for it, I am willing to wait. Until he arrives, I'll make time to dream.

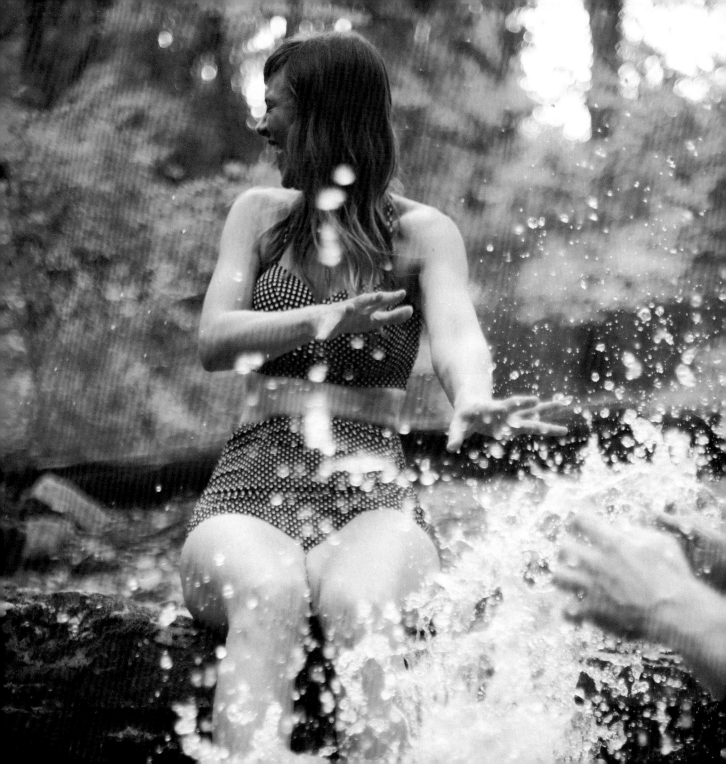

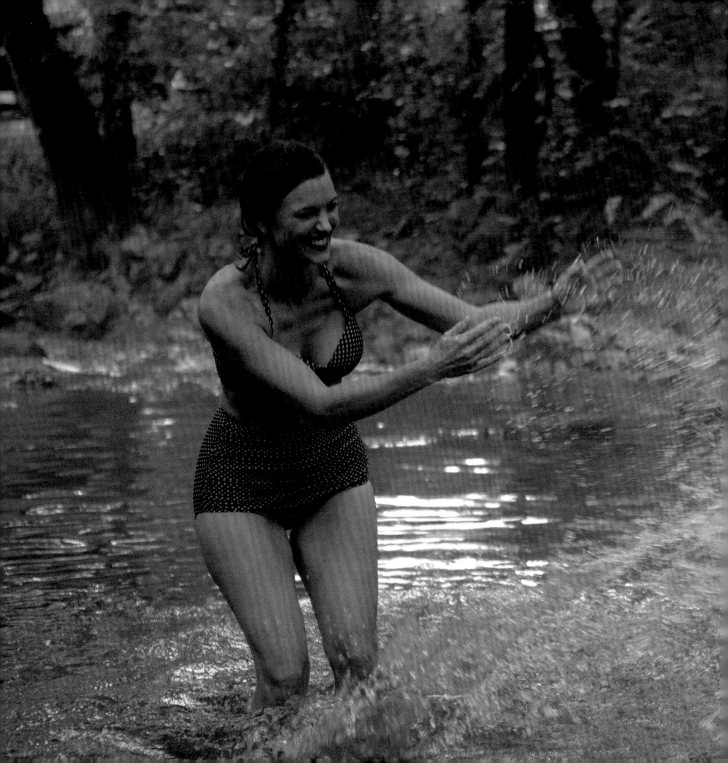

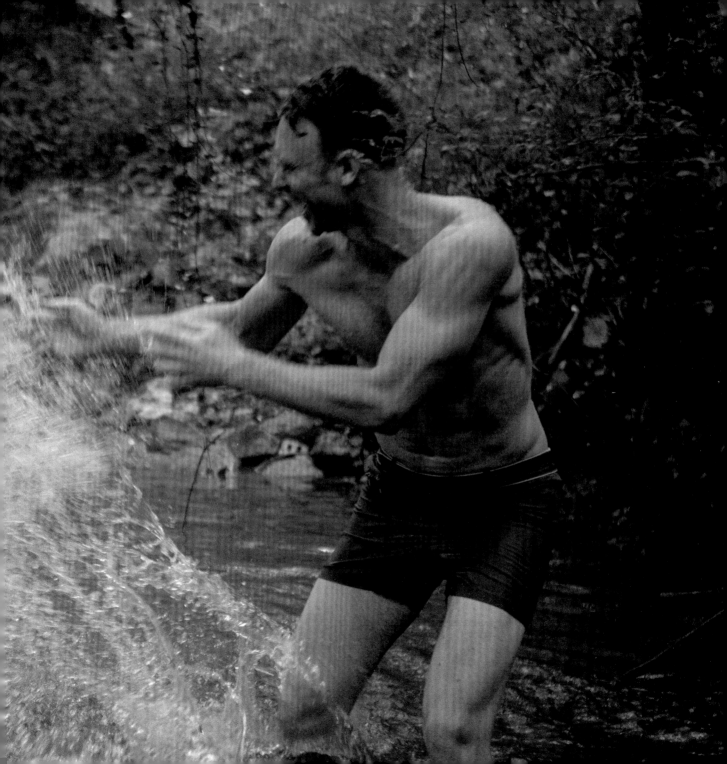

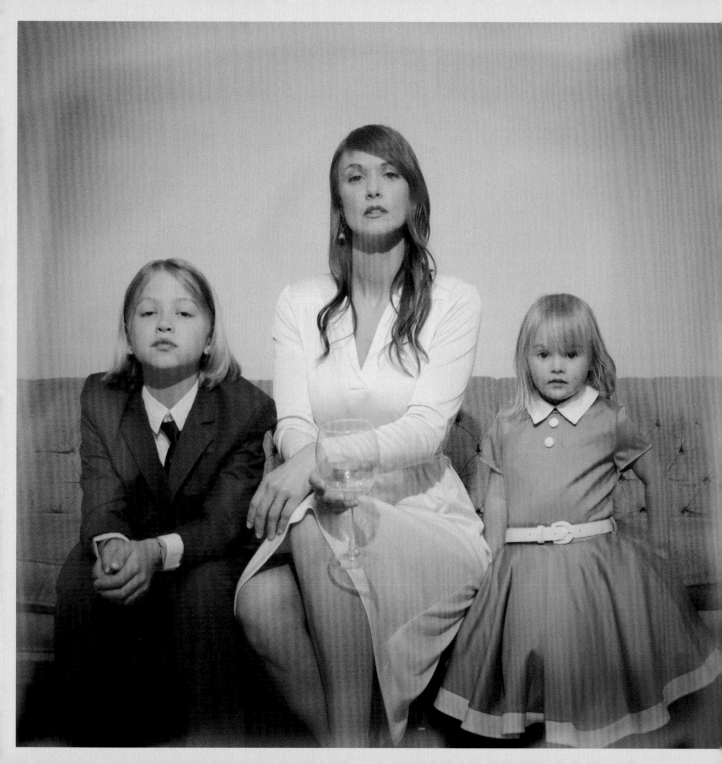

The Kids are Growing Up

We're standing in the checkout line at the grocery store. My daughter reaches over, grabs another pack of gum, and throws it into the cart on top of the bananas, giggling.

"You can't have that," I say and put it back on the shelf.

She can reach everything now. *When did that happen?*

I'm exhausted and fraying at the edges. She hasn't been sleeping much. She's been sick with strep throat and the antibiotics just can't seem to kill it. She wants to be pitiful in my lap and triumphant at the top of a tree in equal measure and neither of us really knows how to manage the strange mix of energy and agony that fills her right now. My son is here too. He's standing in front of the cart, off happily somewhere else in his mind. He's always been a thoughtful, sensitive kid but lately he's seemed more subdued. Sometimes I wonder if he feels lost in the shuffle. I know that sometimes I do.

The cashier's name is Rhonda. She's long and frail, in her mid-to-late sixties, with salt and pepper curls bundled tightly on top of her head. She looks me over; I'm shower-less, stressed, and disheveled. I can barely recognize myself but her face softens like there's a part of me that's familiar to her, beautiful even. Her eyes pause, contemplate, and remember. I meet her gaze, and she smiles.

"Enjoy it while you can. They grow up so fast."

I know that she's right. It's cliché for a reason. And even though I've heard it in passing ever since I became a mother, it hits me harder this time. My son turned

nine in May, my daughter, two in June; he's losing teeth, she's growing them. She's learning to run and he's learning to enjoy stillness. They need me a little less every day, and I feel like I need them a little bit more.

These are the golden years, where joy is common currency and phrases like, "Mama, I love you" play over and over. Despite the pure sunshine that has poured down on us though, we've experienced a lion's share of grey. Our family broke. These kids know the sound of crying through the walls. They watched him, my daughter's father and my son's friend, the man I thought was a part of us forever, slip away from us. They felt my pain deeply, though I hid it as well as I could. We stand close together and we stand strong, but we've worked hard to become that way.

Sometimes, they grow up too fast, I think to myself as Rhonda looks over at my son and smiles.

Our eggs, bread, and more contraband chewing gum travel along the counter in a neat little line, and she scans them with memories written all over her face. I look down at my children—blonde hair getting darker, bodies leaning out and changing shape, new freckles coming in—and I stop to take in her advice. I inhale it like a deep breath and try to hold on to it. I want to feel it amidst the packing of endless lunches and mounds of laundry. I want to remember it when I'm holding my raw-throated daughter in the middle of the night through her tears. I want to know it when I'm reading to my son at bedtime, and he asks for one more page. Time crawls until sunset but by morning, it's already gone.

"You all take care," Rhonda says, patting my son on the head and passing out stickers for him and his sister. We walk out into the parking lot.

Over the course of our busy days together, I try to slow time down one

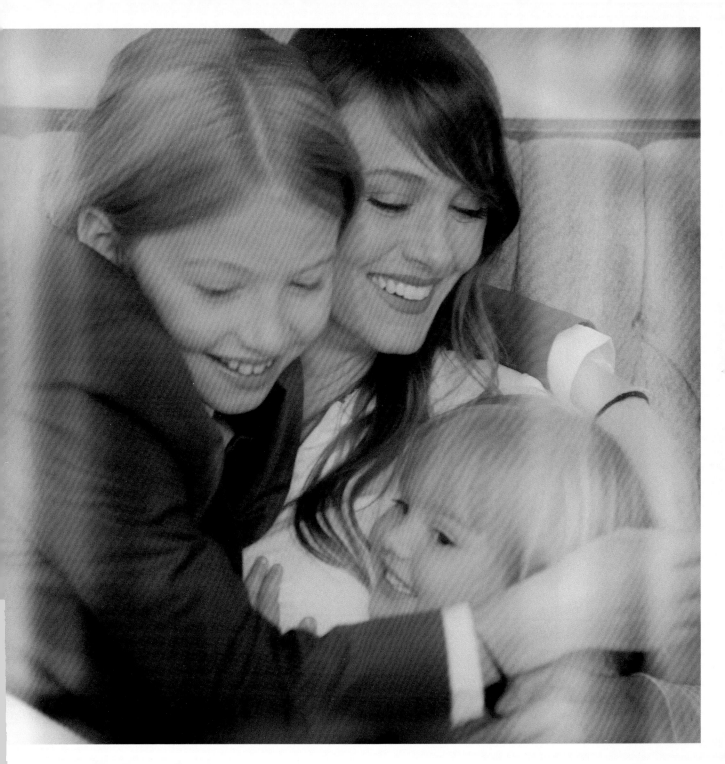

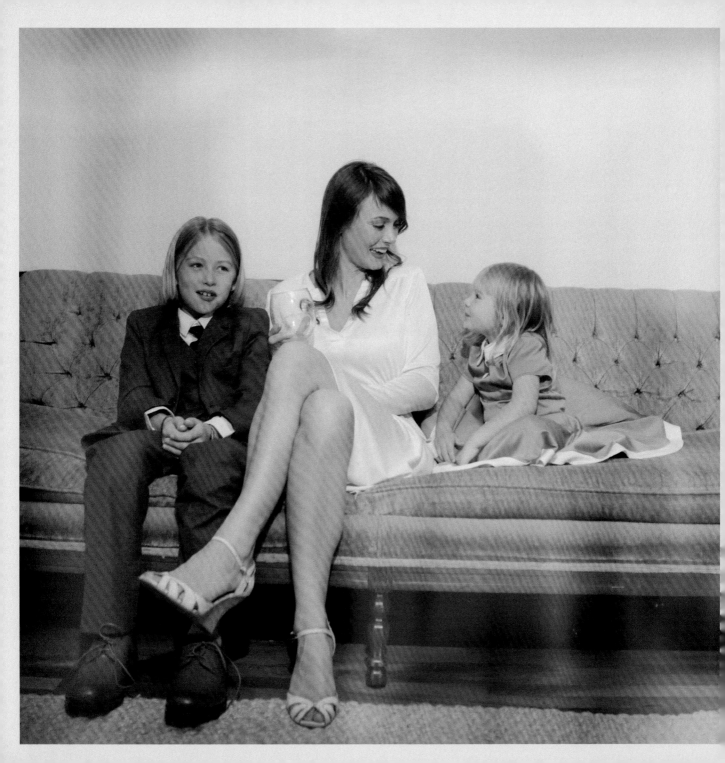

moment and try to speed it up the next. I haven't decided what I want from it, but maybe none of us have. We all just wrestle with the beautiful, painful pace of our existence. We need rest but we can't stand the way it feels to be still. We flash forward and we flash back in our minds with equal amounts of longing. We finally get the kids to bed and sneak in twenty minutes after to watch them dream.

I look back at them in the rearview mirror and thank God for giving me the privilege of being their mother, for making time something to ache over. And it does ache.

When did the clock start to speed up
Hands dizzily spin
Didn't the sun just come up
And go down again

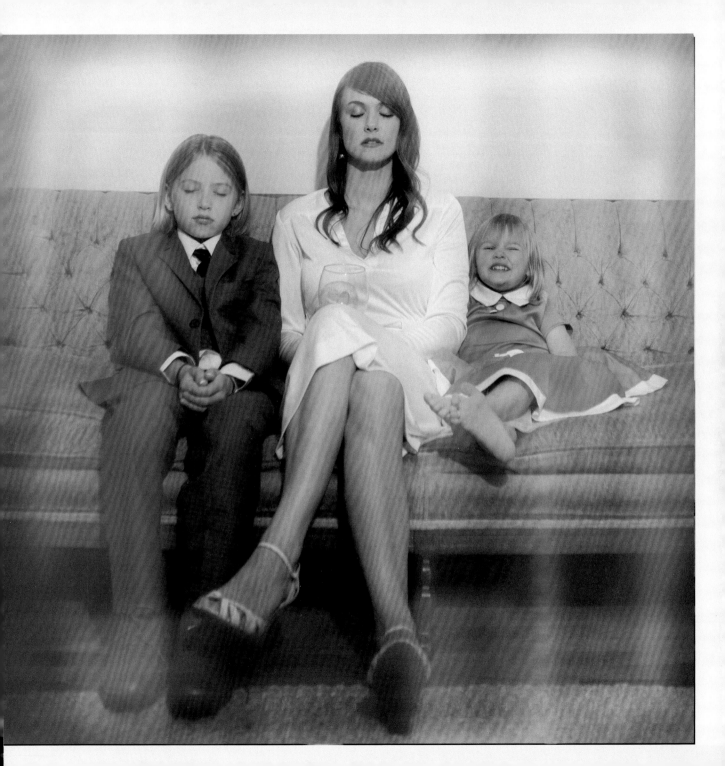

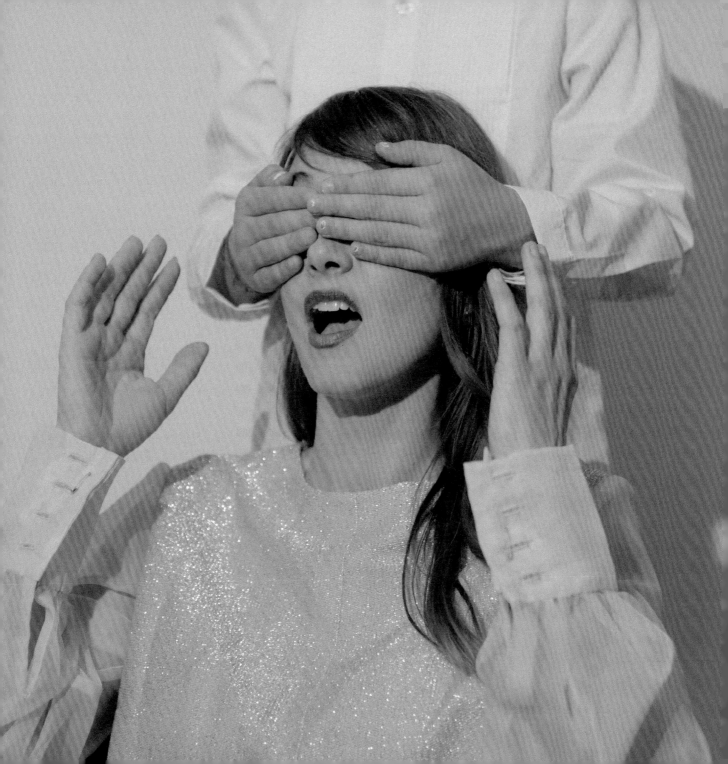

Falling For

I like this lipstick. It's soft and shimmery, and it doesn't make me look like I'm trying too hard. Opening my mouth slightly, I flip down the visor, look into the mirror, and trace my lips with it. My face is tan from repeated trips to the pool with the kids. The color makes me look younger, less drained than I feel. I just turned thirty-eight in May, I've been single now for nine exhausting months and I'm ready not to be. I want to meet someone. I check the little green numbers on the clock, scan my teeth for little green bits of kale from my hurried lunch, touch up my mascara, and dot some blush onto my cheeks.

My car is an icehouse compared to the world outside of it. It's late summer, and the heat hangs over the city like a dirty wet blanket. When I open the door, I feel the sweat climbing to the surface of my skin. I raise my arms slightly so that no humiliating puddles can form there. The coffee shop he chose is small and cheerful. I wonder if he's already there waiting for me.

The building inside is stark white with a curated collection of attractive, leafy plant life placed carefully by windows and on side tables to create privacy. Young professionals sit around staring at their laptops and occasionally taking sips from adorable, bite-sized mugs. A couple sits in the corner booth. They are huddled close together, laughing with their heads back and mouths open. I can't tell whether their love is new or old, only that it seems real.

I want that, I think to myself.

A sharp tinge of hope enters my heart when I see him. He's tall and fit, handsome with hair exactly like the picture on his

profile. He's drinking a glass of ice water and agonizing over what must be an extensive menu of fancy coffee drinks and small plates. He is smiling slightly, his lips parted, revealing white teeth that I can see glistening at me even from a distance. I find myself drawn to his mouth. I wonder if I'll kiss it at some point and what it will feel like if I do. He looks up at me as I get closer. I wait for the overwhelming feeling; the rush of blood, the chemical reaction, the racing pulse, and the roller coaster flood of endorphins. Our eyes meet.

But there is nothing.

For the next hour, we awkwardly talk about our jobs, his dog and my kids, our hobbies, and our pet peeves. We talk about his musical taste, my food preferences, and the places that we've visited that make for good conversation. When we both feel like we know enough, we shake hands, say goodbye, and walk out separately. I climb back into my hot car, disappointed. I won't put my shimmery pink lips to his. He'll never undress me. We won't ever see each other again. This is dating in your thirties, I guess: efficient, sterile, and unapologetic.

I've been out on a few of these dates in the past couple of months. I've gotten dinner, gone hiking, and been swung country-western style all over the dance floor. There has been nothing serious: a hand on my back, a few kisses, some half-hearted flirting. After all of the swiping and bio writing, I've got nothing. I'm trying but I'm scared. I'm looking for something real in a world where eyelashes can be designed in photoshop. I've given my heart away carelessly before, and I've lost pieces of it in the process. I've wandered in and out of relationships, not sure how I ever got there in the first place. I need to look at love differently now. I have two children; I need to be careful, thoughtful, and slow. I'm still learning how, and I'm not sure I like the way it feels to use my heart halfway. I'm not sure I believe in that kind of love.

Behind the good decisions I make, the careful vetting of suitors, and the calculation of risk, I still want to fall. I want to be knocked down by the gravity of someone and sent sailing. Sure, it's dangerous, but I've heard it's worth the risk.

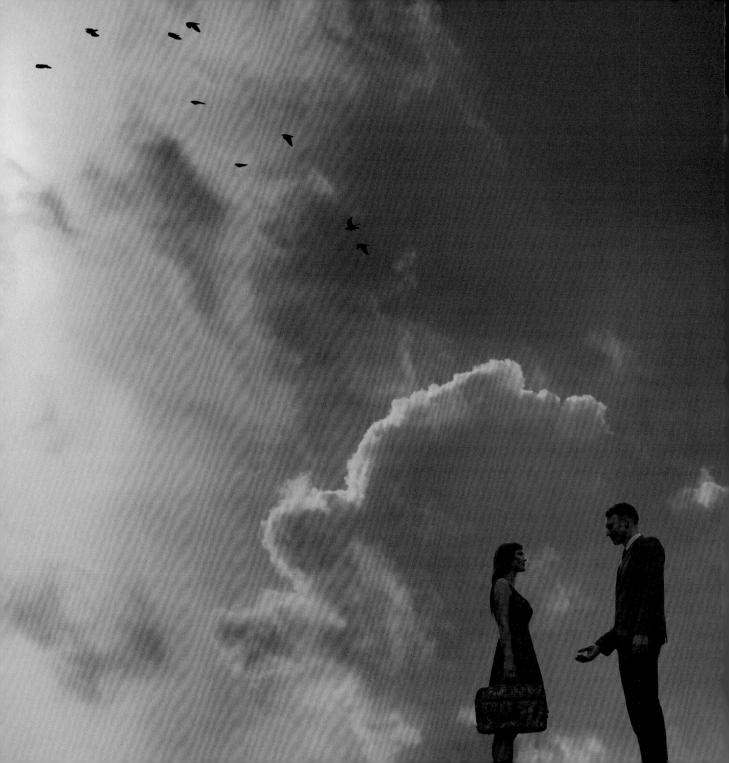

Wherever I End Up

The woods are quiet this morning. The only sounds are my feet crunching the brown leaves beneath them and the fat, hyperactive squirrels scurrying in the underbrush chasing their tails. Sweat is beading up and starting to slide down my forehead, and my red wool coat is growing moist and heavy. It was a poor wardrobe choice for this mild fall weather, but it makes me feel like a kid on her way to Grandma's house, like I'm capable of outsmarting any fairytale wolf that might meet me out here on the empty path.

My thirties have been busy: chasing love, dodging heartache, running toward the future, running away from the past. Escaping to the woods, these woods, thick and dense with bristly cedar and birdsong, where I know I can find peace. I've cried under the cover of these branches, mourning relationships and putting them to rest next to big stacks of moss-covered rock. I've prayed, shutting my eyes and opening my ears, begging for affirmation, guidance, a bit of a break now and then. Also, for love. I don't need to escape anymore. I'm not out looking for a safe place.

A few weeks ago, I heard a knock on my front door. I jumped up from the couch barefoot and skipped happily through the foyer. The door, which has always been reluctant and heavy, felt oddly light in my hand as I pulled it open and faced him for the first time. He was tall and slender, fit and handsome, dressed in a plain blue t-shirt and shorts. I didn't notice any of that at first because of his eyes. They were sky colored and full of recognition. It was as though we'd been

staring at each other, loving each other for years and years. He was smiling at me with his whole face, and I was smiling at him with mine. We had only ever spoken on the phone, but I could feel my whole life changing by the second.

I invited him in for coffee, and we sat next to each other on the couch. He grabbed my hand and held it in his for the first time. We scooted close and nervously chatted about our days and how crazy it was that he was actually here. Conversation became easy quickly. It was a steady stream of kids and careers, childhoods, and past relationships. We talked about his adolescent obsession with flying and my love for music. We laughed our heads off as we dreamed up skits for the show that we made up called, "Shitty Night Live." I found myself laughing until I couldn't breathe, mouth open wide, with my head thrown back. I had been estranged from that feeling for so long.

I laid my head in the crook of his neck and exhaled, releasing more than breath, but also years of disappointment and longing. He held me, and his eyes toured the room, a space he'd gotten to know in great detail over the course of our countless hours-long evening chats on the phone. Then, he shifted his gaze to mine. He looked at me in a way that nobody ever had before, with deep, tranquil eyes I had only ever seen on a riverbank in my sleep. I felt at peace. Every step, every day that felt wasted, every dream that felt unrealized, every escape to the woods had led me to him, and every step afterward would be different.

A cardinal suddenly warbles its song at me, and I smile, remembering that first moment of loving him. I approach an awning of maple that opens up into the yard of my home, a home that for so long felt like it was missing something. The branches hang low over me, and the wind whistles. There are no wolves here,

no paths too twisted or terrain too rugged to walk. The sun travels through the clouds, through the cover of the canopy, and onto my cheeks—now as red as my coat—and I know that this peaceful place is where we will marry.

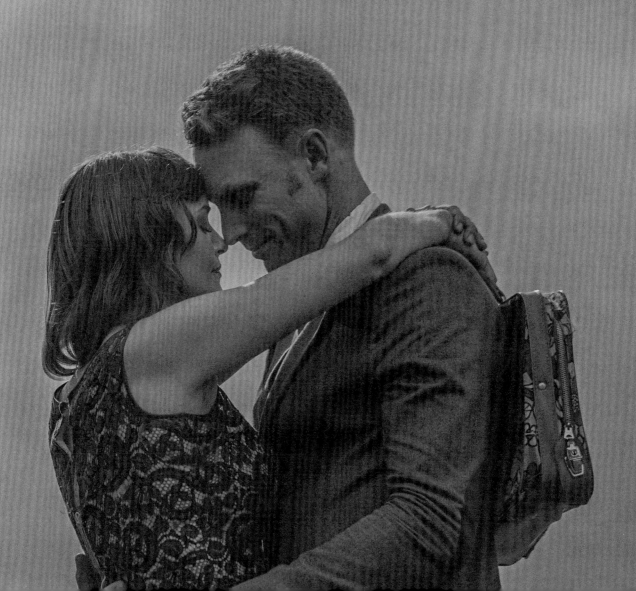

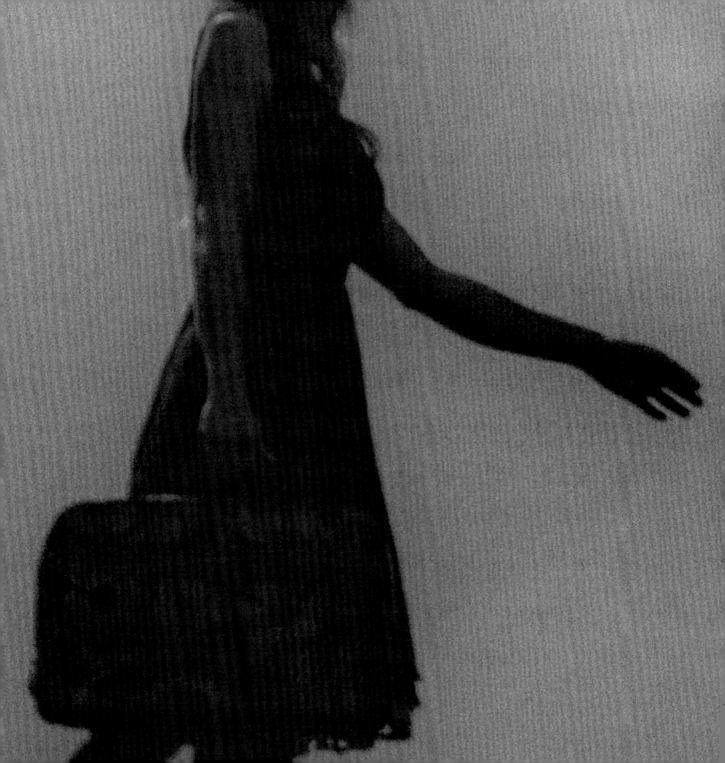

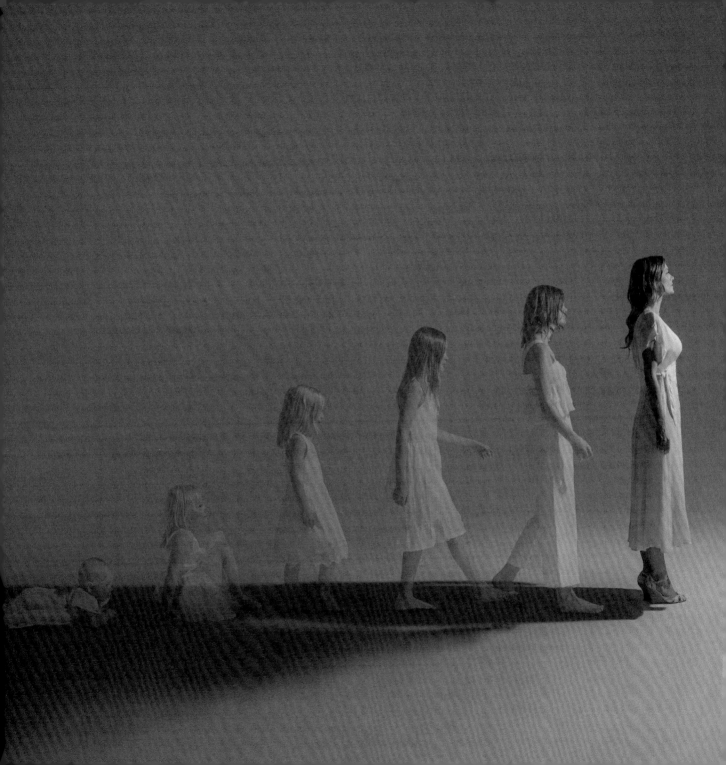

The Way to Go

A little blonde girl with bangs and baby teeth looks up at me from an old photograph. She's wearing a handmade dress with the name "Annie" all over it in bubbly craft store font, doing its best to match the letters that sit above Shirley Temple's face on the VHS sleeve. The girl in the picture is only about four years old; her smile is there but it's slight. She's playing it safe with her emotions, always on her best behavior, at least most of the time. Later that year, she'll take a pair of safety scissors to a single pigtail in the upstairs bathroom and hide the fallen hair behind the laundry basket. In her five-year-old picture, she'll have a razor-sharp bowl cut.

I think for a few minutes, staring down into this girl's face. She looks like my own daughter: blonde-haired, curious, and wanting to make people happy. She feels like a daughter to me. My mind wanders and I find myself walking backwards into my childhood home on Gregory Street. It's a drab earth tone, three-bedroom house across the street from a golf course in the middle of the suburban Illinois flats. I push on the heavy front door, and it reluctantly obliges by opening slowly. I step onto the stone floor and remember the way my feet sounded as I ran through the landing, playing tag with my older brother. He was much faster than I was, and I slipped on the rug chasing after him. The tiny scar still sits on my chin.

The hallways are linoleum. I follow them until they open up into the kitchen where there is more linoleum, and I see her. She's sitting at the dining room table shaded from the morning sun by a pair

of blue and white curtains hanging tiredly over the window. I smile when I see her. She's wearing pink terry cloth pajamas and eating a bowl of Raisin Bran, all crunching and cheeks and straw-colored hair. We are alone.

I walk towards her and pull out a wooden chair that I've sat in an incalculable number of times. It creaks a little when I sit down; it always has. I scoot in close to her. She's so innocent, so pure: bopping her head and humming a little song, legs swinging underneath her, still relishing in the freedom of her grown-up chair. I look into her eyes without hesitation; she looks back into mine. My hands reach across the table, and she grasps them. Her expression changes, like she's wondering why I've come.

I've practiced this moment so many times in my head. I thought

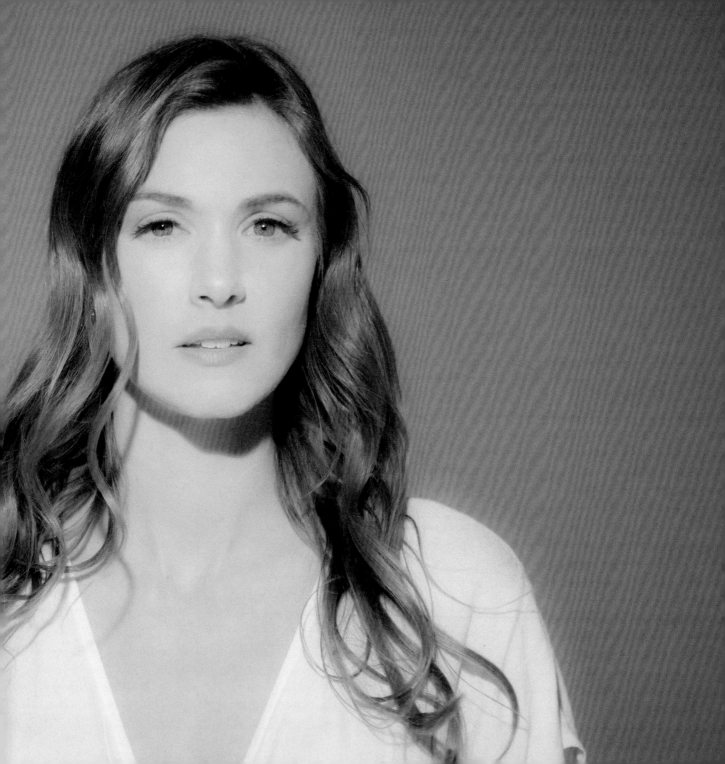

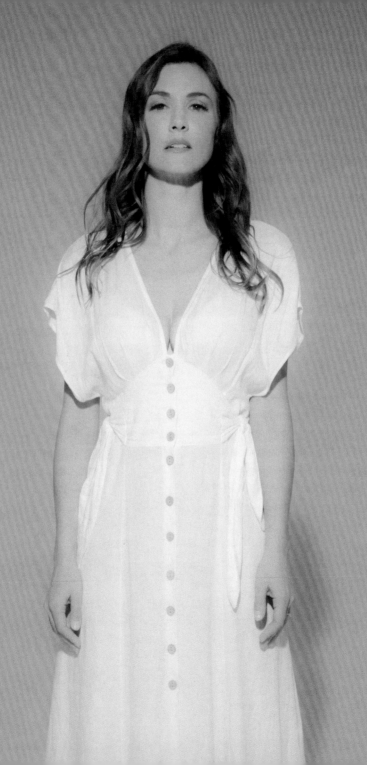

I would run to her, flailing my arms and rolling out the long list of hurt and failures that she would inevitably face, warn her of the broken relationships, the people that would treat her badly, the bad decisions that she would make, and the shame that would, at times, almost knock her down. I wanted to tell her about all of the crossroads that she would come to where she shouldn't turn left or right but go back to where she came from—but there are just too many directions. I start to get flustered and begin to speak. I know that I have to be thoughtful. Words matter to her, and above anyone else that she'll ever know, my words matter the most.

I stare at her, sitting there in her pink footie pajamas, with her fat brown bear that she calls "Daisy" propped up in her lap. Her round face carefully cradles two familiar sleepy blue eyes. I picture my children beside her—she has my daughter's thoughtful brow and my son's chin. She shares their beauty and goodness. And one day, despite the hardships and loss that she will face, she will be a mother to them. She will love them fiercely, with every piece of herself. She will guide them and care for them the best way that she knows how. I lean in close and take her face into both of my hands. I gently kiss her forehead and simply say nothing. She already has everything she needs.

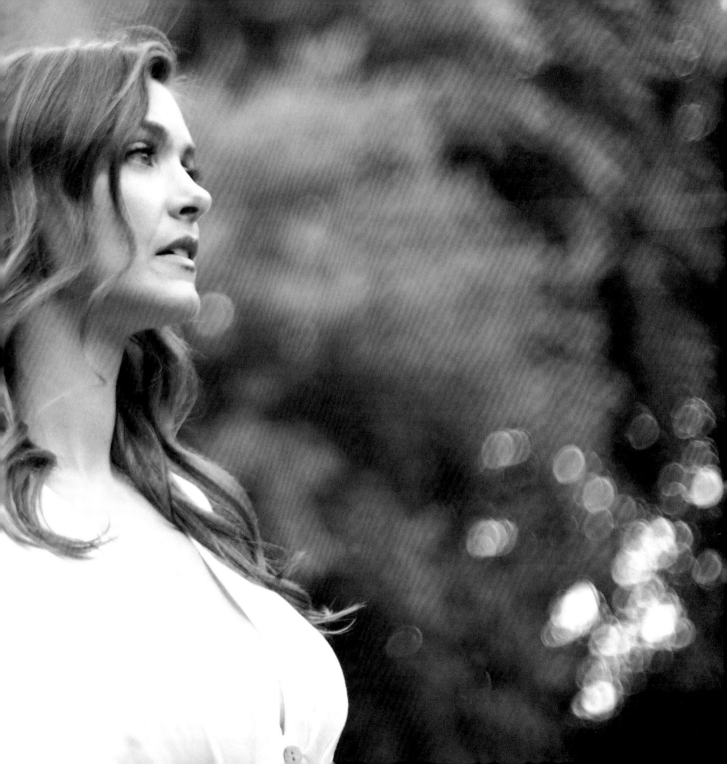

Acknowledgements

I cannot tell you how many grand dreams I have let die before they ever had the chance to take their first breath. Without the help of these people, this book definitely could have been one of them. Thank you to Fairlight Hubbard for all of the beautiful pictures that you took. You helped me turn thoughts in my head into the incredible images on these pages. Thank you for being who you are and for walking alongside another artist like myself. Thank you to Shannon Lee Miller for your direction with the content of this book. It was amazing to learn from a real pro like yourself. I really appreciate all of your endless encouragement through this process. You are a true light.

Thank you to Erin, Stephanie, Maggie, and Madeline at Olivia Management for believing in this project from the very beginning and helping me to expand myself as an artist. It's such a privilege to work with you all. Thanks to Asha Goodman at Saks and Co. for getting behind this project and putting it in front of people's eyes. Thank you Peter Groenwald for being in tons of these pictures. I know you could've spent your time doing other things besides dancing with me awkwardly or celebrating a pretend wedding but I'm glad that you spent it with me. Thank you to Jerred Cooper for freezing your very cute tush off in severely cold water and being so calm about almost stepping on a snake. It was easy taking all these lovey-dovey pictures with you, because we are so in love.

Thank you to the folks at Dexterity Publishing—Matt West, Kathryn Notestine, and Jeff Godby—for all of the hard work that you've put into this project. And much gratitude for thinking that it was ever publishable in the first place.

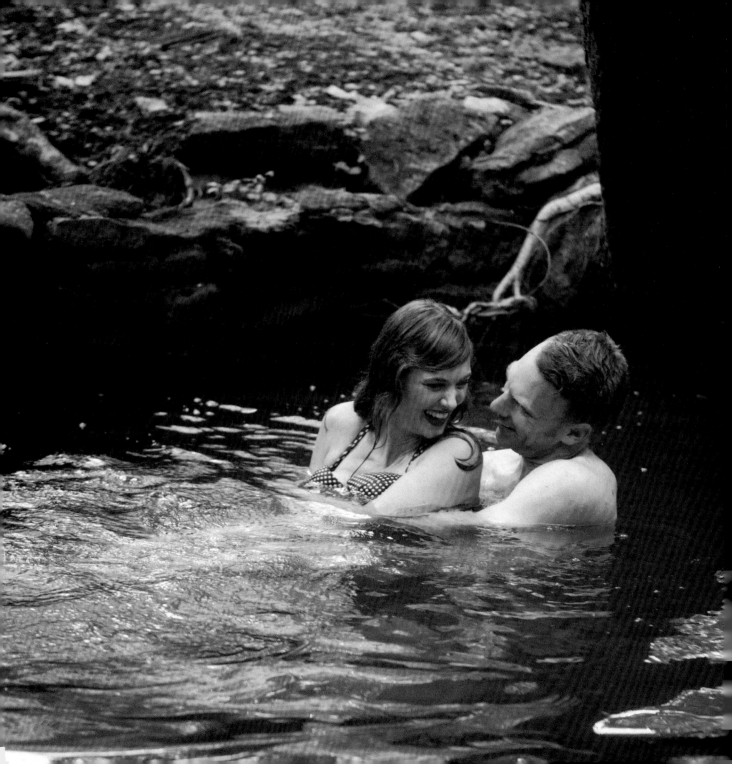

Models

Sorry Now: Jill Andrews and Jerred Cooper

Sold My Heart: Jill Andrews and Peter Groenwald

The Party: Jill Andrews, Goldie, Peter, and Amelia Groenwald

Gimme The Beat Back: Jill Andrews and Peter Groenwald

Back Together: Jill Andrews and Peter Groenwald

My Own Way: Jill Andrews and Rose the horse

River Swimming: Jill Andrews and Jerred Cooper

The Kids are Growing Up: Jill Andrews, Nico Darrah, and Falcon Sayles

Falling For: Jill Andrews and Nico Darrah

Wherever I End Up: Jill Andrews and Jerred Cooper

The Way to Go: Goldie Groenwald, Falcon Sayles, Amelia Groenwald, Sparrow Luca, Indigo Pyles, and Jill Andrews (in order of appearance)

*Photo on right by Rachel Bullard

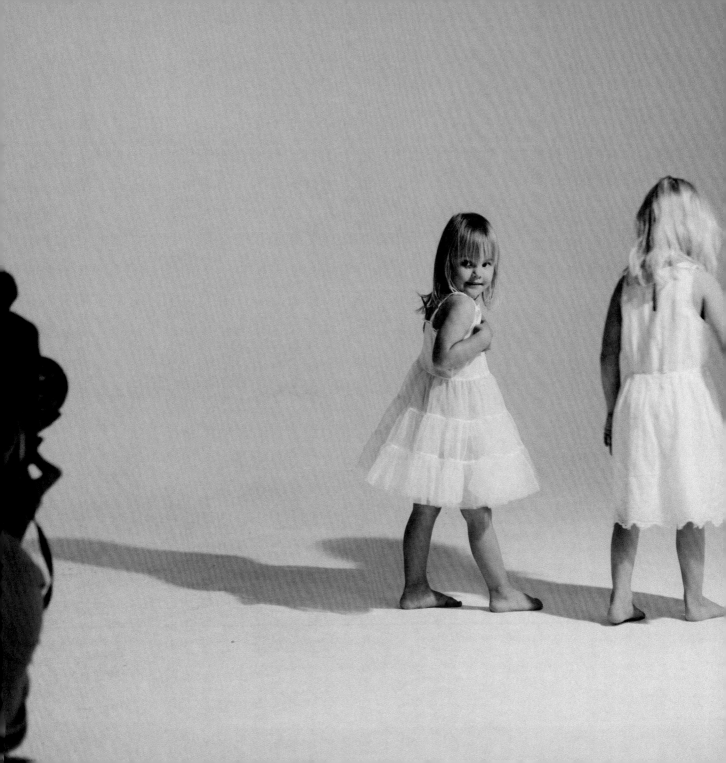

About the Author

Jill Andrews is a Nashville-based singer-songwriter whose songs have been featured on television shows such as *Grey's Anatomy, Nashville, and American Idol.* She has collaborated and shared the stage with countless celebrated artists, including The Avett Brothers, Langhorne Slim, Willie Nelson, The Civil Wars, and Drew Holcomb and the Neighbors.

From her days fronting lauded Americana group, the everybodyfields, to her successful solo career as a writer and performer, Andrews's music has taken her far from her East Tennessee roots. She is a graduate of East Tennessee State University where she studied Psychology and Criminology. Andrews lives in Madison, Tennessee, with her husband Jerred and her two children, Nico and Falcon. *Thirties: The Album in Portrait and Prose*, Andrews's first book, is the companion to her fourth album, *Thirties*.

For exclusive demo versions of songs from
Thirties and to listen to the full album, visit:

jillandrews.com/bookextras

Thirties is available on vinyl, CD and digitally wherever music is sold.